Remembering
Winston-Salem

Wade G. Dudley

TURNER
PUBLISHING COMPANY

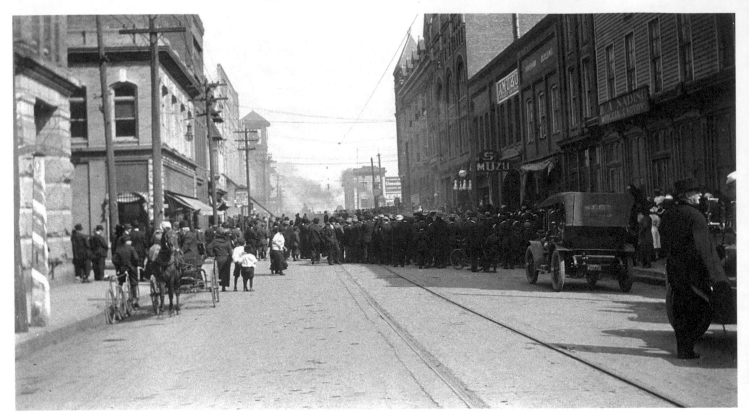

Traffic and bystanders block Fourth Street as the O'Hanlon Drug Store burns to the ground in 1913.

Remembering
Winston-Salem

Turner Publishing Company
www.turnerpublishing.com

Remembering Winston-Salem

Copyright © 2010 Turner Publishing Company

Library of Congress Control Number: 2010926211

ISBN: 978-1-59652-687-7

Printed in the United States of America

ISBN: 978-1-68336-907-3 (pbk.)

CONTENTS

Pharmacist Edward W. O'Hanlon chose to replace his old building on the corner of Fourth and Liberty streets with a nine-story brick building, completed in 1915 and generally recognized as Winston-Salem's first skyscraper.

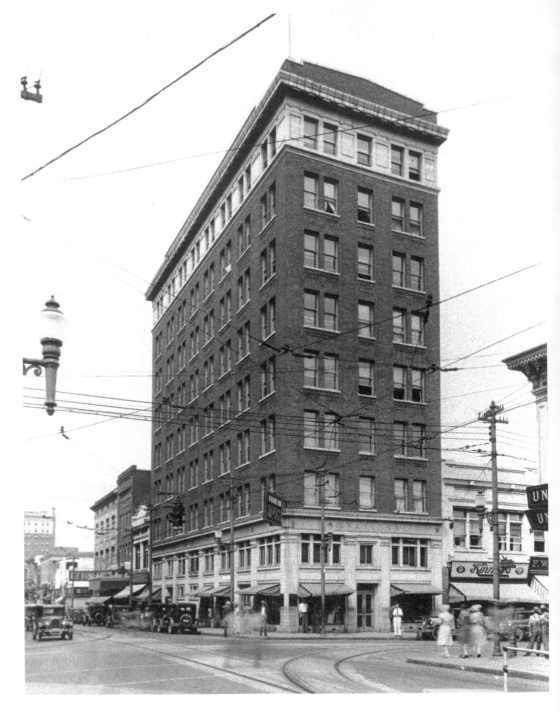

Acknowledgments

This volume, *Remembering Winston-Salem,* is the result of the cooperation and efforts of many individuals and organizations. It is with great thanks that we acknowledge the valuable contribution of the following for their generous support:

Forsyth County Public Library
Library of Congress
North Carolina State Archives

Thanks to the always helpful staff of the Verona Joyner Langford North Carolina Collection at East Carolina University.

With the exception of cropping images where needed and touching up imperfections that have accrued over time, no changes have been made to the photographs in this volume. The caliber and clarity of many photographs are limited by the technology of the day and the ability of the photographer at the time they were made.

PREFACE

In 1753, fifteen weary Moravian men reached the Crown colony of North Carolina. The first of many Moravians to walk the Old Wagon Road from Pennsylvania or face the hardships of travel upriver, then to cross trackless Carolina wilderness, they settled on 100,000 acres of land purchased from the last of Carolina's Lord Proprietors: John Carteret, Earl of Granville. By 1766, settlers began building a new Moravian town: Salem. Governed under the edicts of the church, Salem prospered, its citizens thriving as farmers, merchants, and manufacturers. Other North Carolinians came to know the people of Salem as people with good hearts, always willing to help others in need.

In 1849, Salem granted land to the state for a new village a mile or so up the road. It would be the seat of a new county, Forsyth County. The town fathers of Salem felt that a "worldly" courthouse, and the people attending court sessions therein, would be disruptive of the Moravian way of life. A little later, this sleepy hamlet received the name of Winston, and over the next decades some of its inhabitants became industrialists with overflowing purses.

Built on profits from bright leaf tobacco and textiles, Winston prospered from 1880 to 1900. It embraced the modern age of electricity: utility poles lined its streets and electric trolleys carried its workers to their jobs by 1890. Most of Salem's citizens felt a kinship with the good people of Winston, especially as expansion brushed away previous boundaries. By 1900, both groups called themselves, unofficially, the Twin City.

In 1913, Winston-Salem incorporated. Already the leading economic power in North Carolina, the city kept expanding, especially after the automobile arrived. By then, a very wealthy group of citizens had been granted de facto control of Winston-Salem. They frequently used their money for the good of the city, especially to improve the city's image. By 1929, skyscrapers created an impressive skyline—and then, the sky fell.

The years of the Great Depression, followed by World War II, seemed to leech the life from Winston-Salem. The economy stayed relatively strong, one of the ten strongest in the United States, but to maintain its pace during the depression and to increase that pace during World War II meant corners had to be cut. By 1950, a dirty, shabby city with a broken infrastructure needed strong leadership to revitalize its streets, buildings, and people.

Despite challenges, Winston-Salem rose to the occasion, becoming a model city by 1959. Politicians visited, businesses boomed, and a major college relocated to Winston-Salem. The 1960s brought cold war, integration, and business worries to the fore, but again, citizens rose to the occasion.

This book is the story of two dynamic communities that joined forces to build a single city where mere villages once stood. The period covered stretches from the 1880s to the 1960s. It is a history, of sorts, but a history told primarily with photographs: seconds in time captured by the flash of a camera. Words can be twisted, but images offer a glimpse of things very solid and real. This is, of course, a study of change; but in the end, one may just discover that the most important things have not changed at all.

—*Wade G. Dudley*

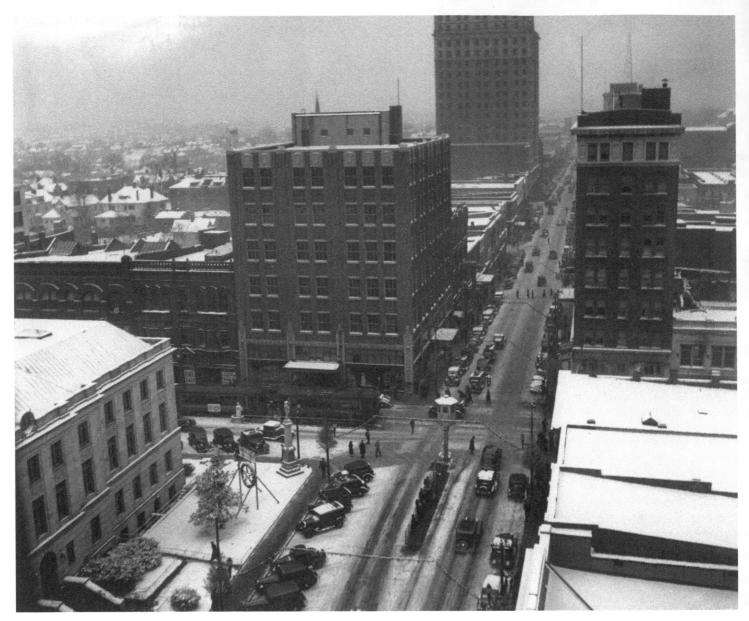

The distinctive, white-faced top floor of the O'Hanlon Building stands out in this view across the roofs at the intersection of West Fourth and Liberty streets around 1935. Directly opposite stands the Pepper Building, and the Forsyth County Courthouse is in the left foreground. It had replaced the lovely but outdated Romanesque courthouse in 1926.

Winston and Salem

(1880–1899)

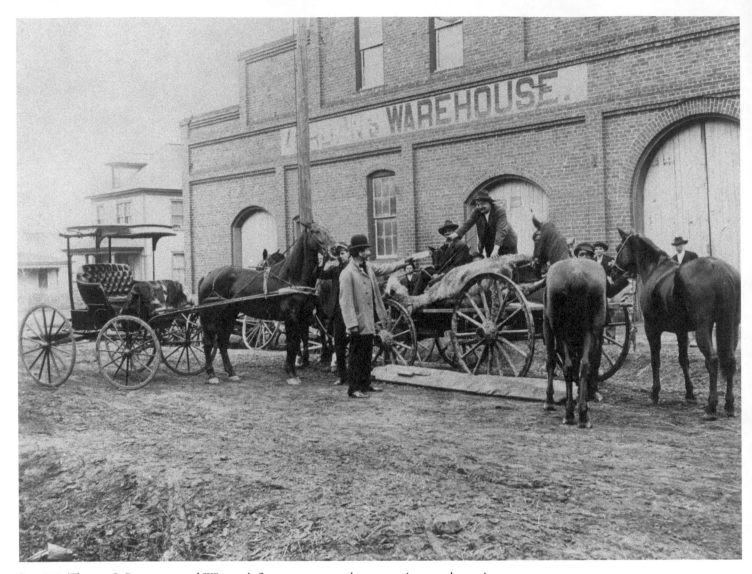

In 1872, Thomas J. Brown opened Winston's first permanent tobacco-auction warehouse in a wooden building on the corner of Church and Third streets to exploit the growing bright-leaf tobacco production in the county. Success followed, and Brown opened an 18,000-square-foot warehouse in 1884 on Main Street. This photo from around 1885 illustrates that business never stopped, even during the off-season.

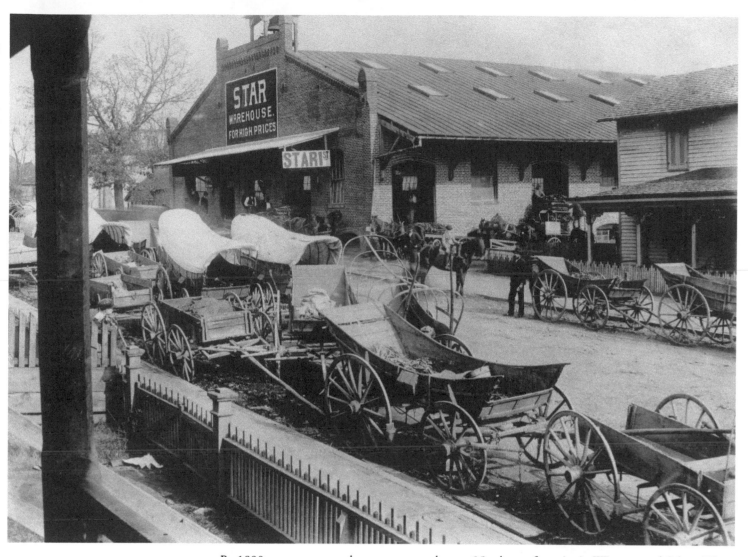

By 1890, numerous warehouses supported some 35 tobacco factories in Winston and Salem. These empty wagons outside Star Warehouse on North Main Street mark the last days of another successful season, and serve to illustrate that tobacco supported more than just warehouses and chewing-tobacco factories. These were probably built at the Nissen Wagon Works or at Spach Brothers Wagon Works, business competitors since the 1830s profiting from the need to haul the bright leaves.

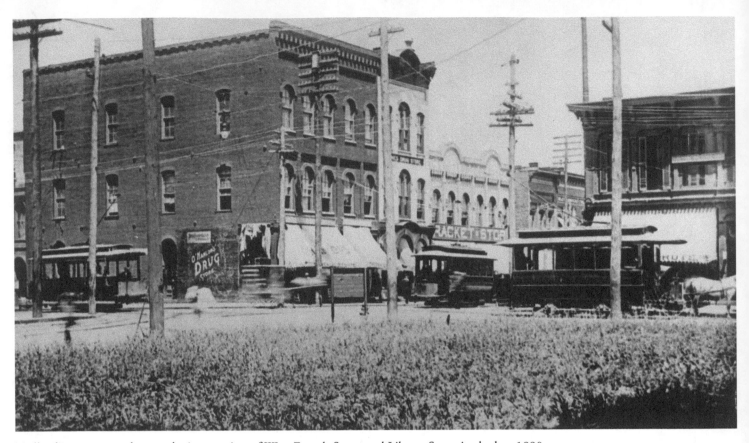

Trolley lines converge here at the intersection of West Fourth Street and Liberty Street in the late 1890s.

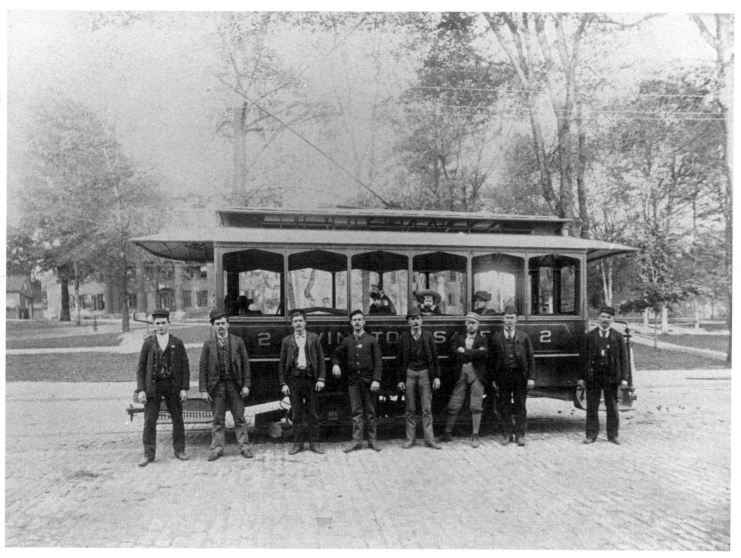

Winston and Salem entered the electric age in 1890 with the introduction of telephone service and electric streetcars. In this photograph, conductors pose near one of their charges in Salem Square.

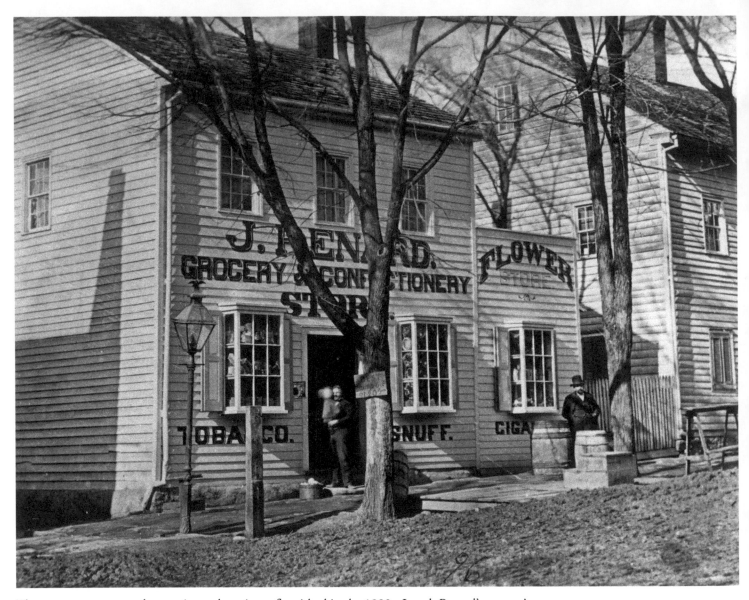

The corner grocery, nearly gone in modern times, flourished in the 1890s. Joseph Renard's enterprise sought to profit by sustaining both body and soul of its customers, combining a grocery store with a florist shop.

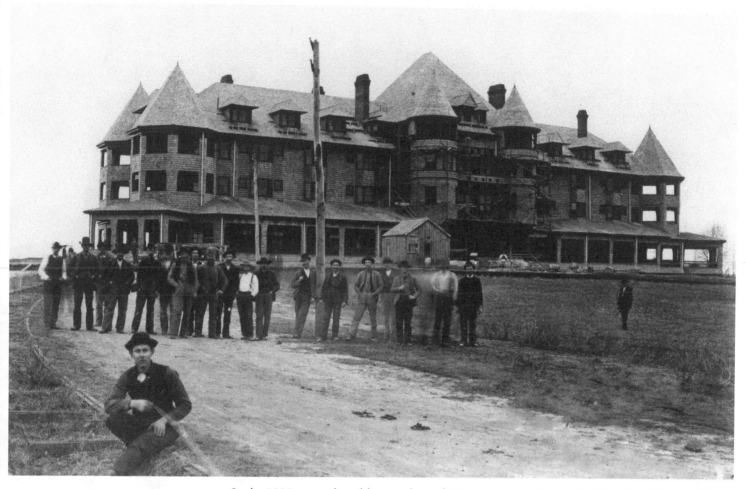

In the 1880s, several wealthy members of Winston society formed the West End Hotel and Land Company. They built a magnificent structure, Hotel Zinzendorf, on the west side of Winston. Completed in May 1891, the hotel featured steam-heated rooms, bathrooms on every floor, and top-notch service. The first tourist magnet in the area seemed well on its way to success.

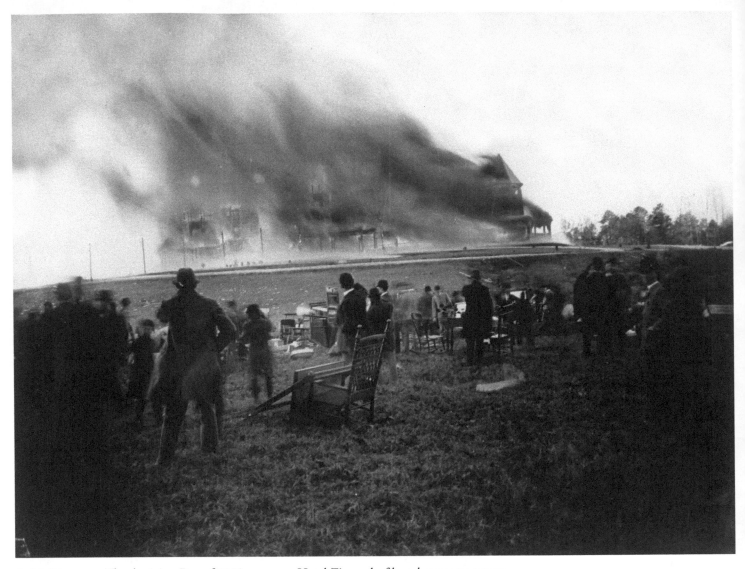

At 11:00 A.M. on Thanksgiving Day of 1892, guests at Hotel Zinzendorf heard someone scream "Fire!" By the time fire companies from Winston and Salem arrived, flames had spread from the laundry room to engulf the structure. By the next morning, only brick chimneys and ashes remained of Winston's first experiment with tourism.

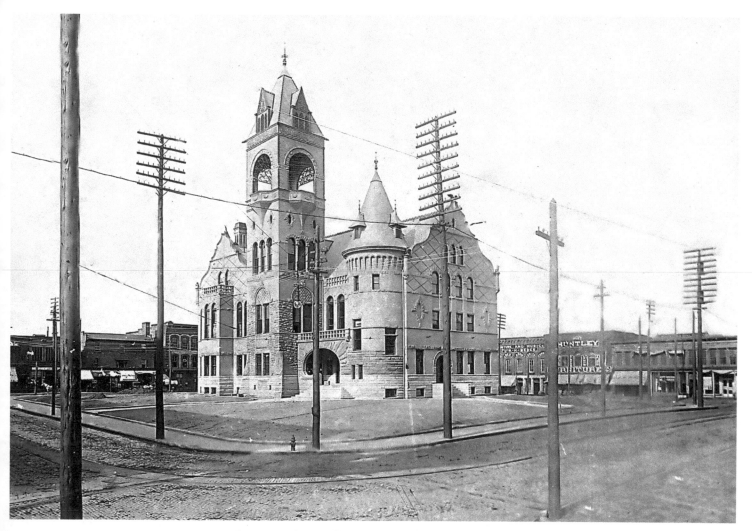

Architect Frank R. Milburn designed the replacement for Forsyth County's old courthouse. Built of granite, brick, and brownstone, the new courthouse with its Romanesque design impressed all who viewed it. Dedicated in 1897, it embodied the growth and economic power of Winston, Salem, and Forsyth County.

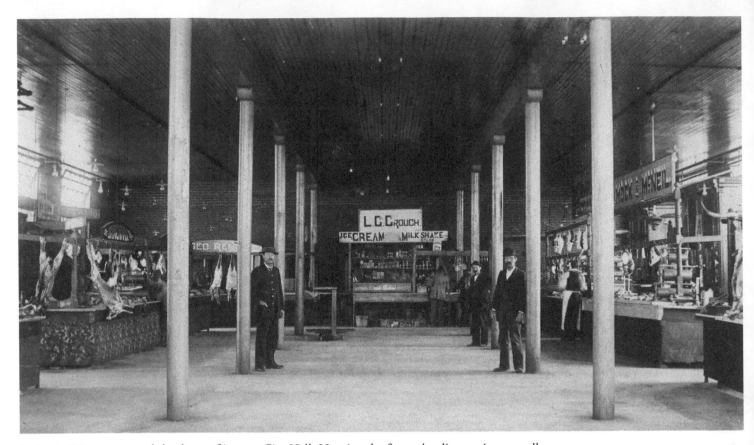

In 1893, Winston opened the doors of its new City Hall. Housing the fire and police services as well as the town's public officials on its upper levels, the building offered rentable market stalls along part of the lower floor. Located on the corner of Main and Fourth streets, City Hall featured a four-story clock tower.

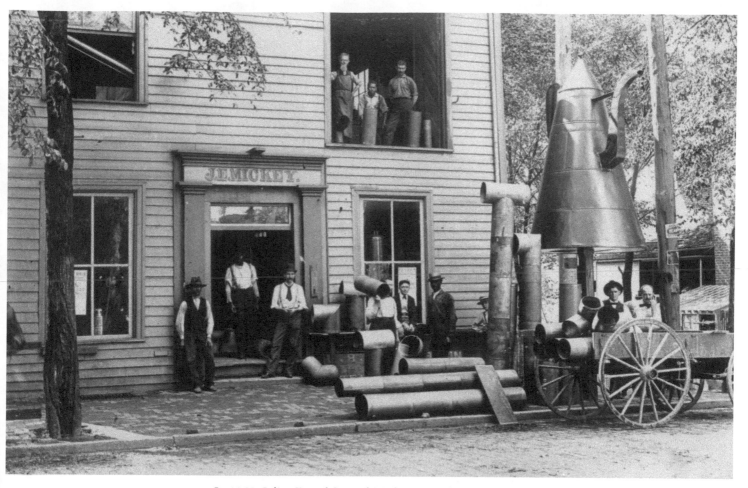

In 1858, Julius E. and Samuel Mickey opened a tinsmith shop. To advertise, they placed a giant, tin coffee pot outside the shop. Photographed so frequently—as in this shot from the 1890s—that it became the unofficial symbol of Winston-Salem, the pot remained a fixture in front of the old J. E. Mickey Shop until 1959, when the city relocated it elsewhere on Main Street.

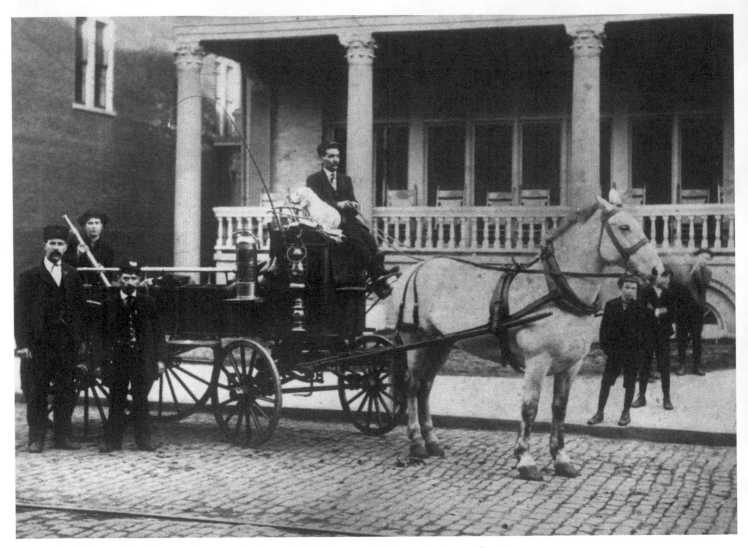

Winston's ladder truck and crew, photographed around 1898, proved their worth time and again as fire ravaged the wooden buildings that housed much of the city's industry and most of its citizens.

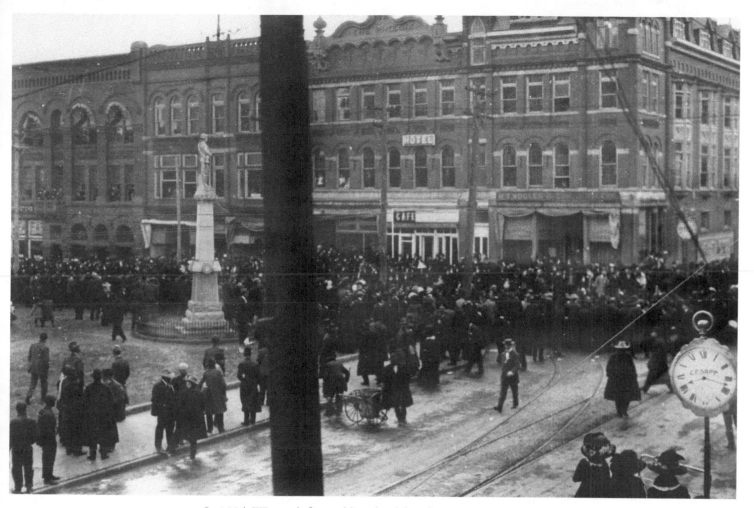

In 1894, Winston's first public school for whites, West End Graded School, opened its doors. The first public school for blacks, Depot Street School, opened in 1897. These schools marked a commitment to literacy in Winston, especially by the city's wealthy elite. This photograph of a school parade in Winston probably dates to 1895 or 1896.

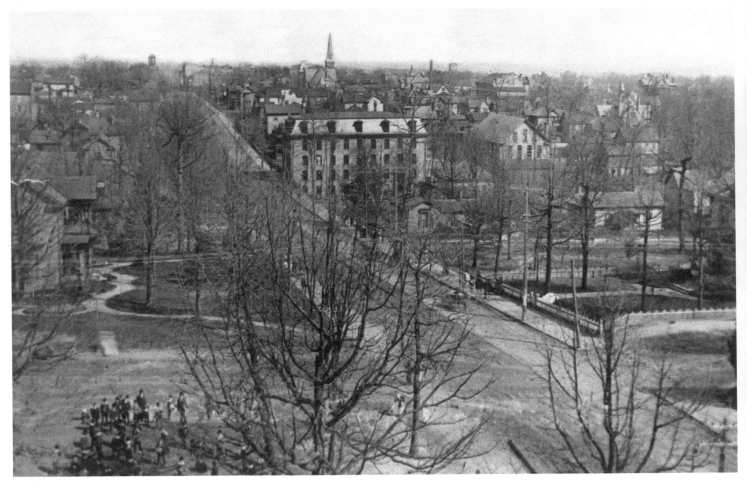

This is a winter view of West Fourth Street from Broad Street taken sometime in the 1890s.

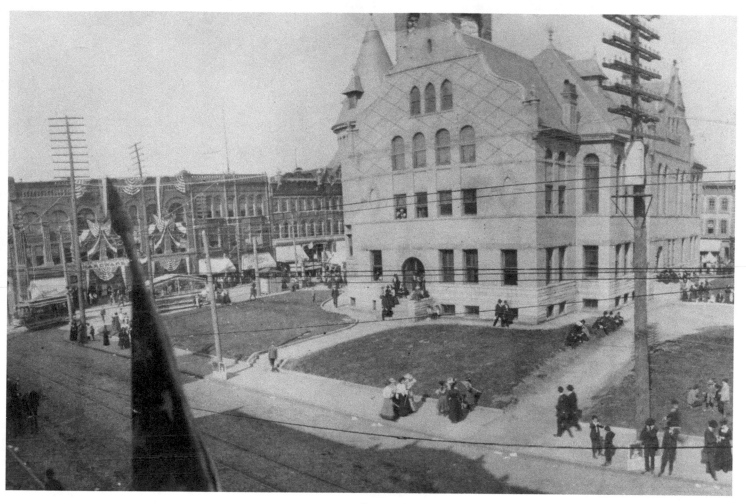

Court is in session at the Forsyth County Courthouse in the late 1890s.

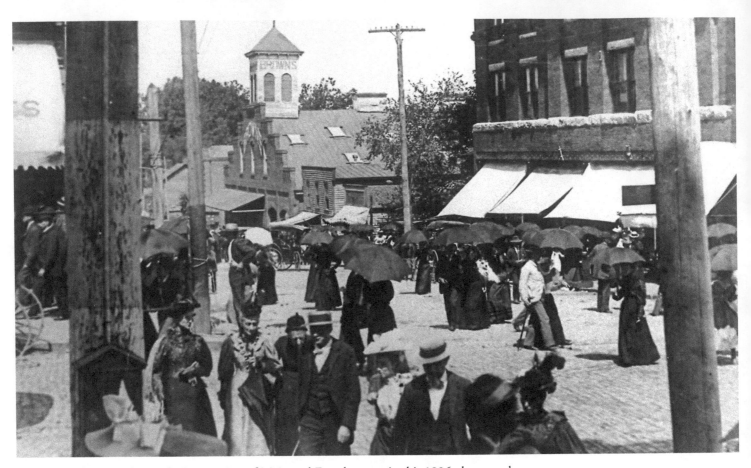

Prosperous shoppers throng the intersection of Main and Fourth streets in this 1896 photograph. They reflect the amazing growth of Winston, and the hope that marked the Gay Nineties in America.

THE GOOD TIMES

(1900–1929)

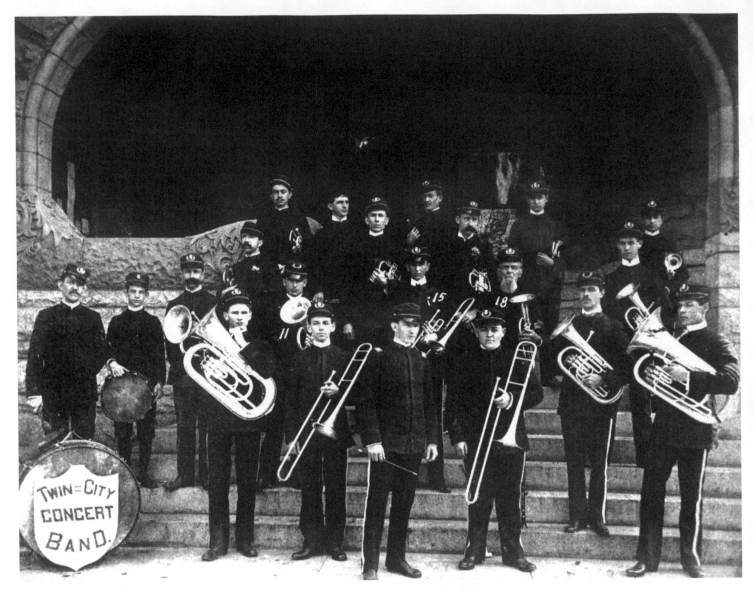

As Winston and Salem ushered in a new century, their citizens increasingly thought of them as one municipality. Thus the Twin-City Concert Band, pictured here in 1900, exemplified not just a desire for culture or entertainment but the very real desire for a merger of Winston and Salem.

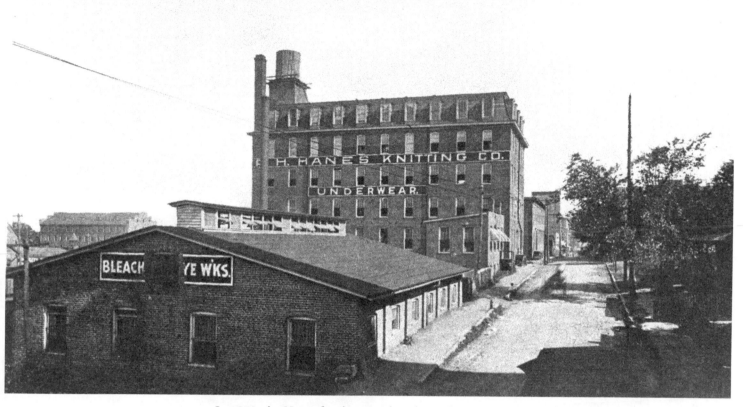

In 1873, the Hanes family opened a tobacco factory in Winston that eventually employed over 600 people and processed more than 3,000,000 pounds of tobacco per year, making it the largest such factory in the United States at that time. The Haneses sold their business to R. J. Reynolds in 1900 and began construction of P. H. Hanes Knitting Company at Sixth and Church streets. Success in the tobacco industry allowed such diversification in Winston-Salem again and again.

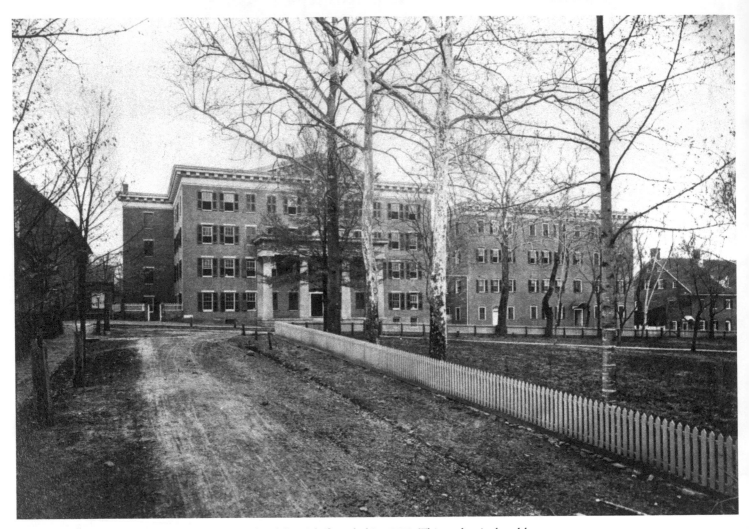

Salem College traces its roots to a Moravian school for girls founded in 1772. This makes it the oldest educational institution in North Carolina. When this photograph of its campus was taken, around 1900, Salem Academy and College included a preparatory school for young ladies.

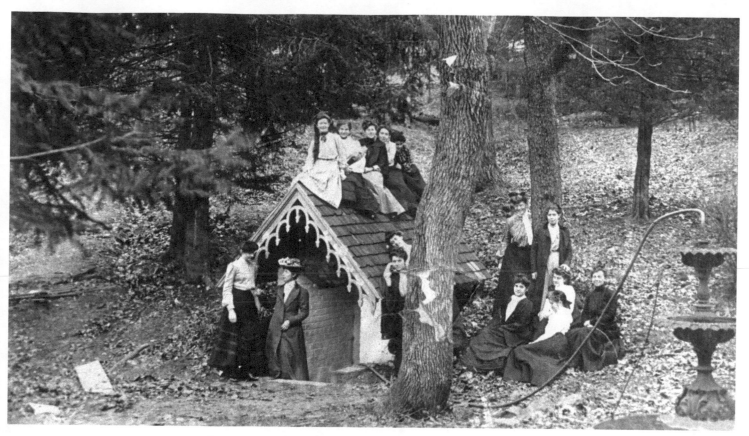

In 1903, as today, college meant socializing as well as study. Here, students relax at the Salem College Spring House.

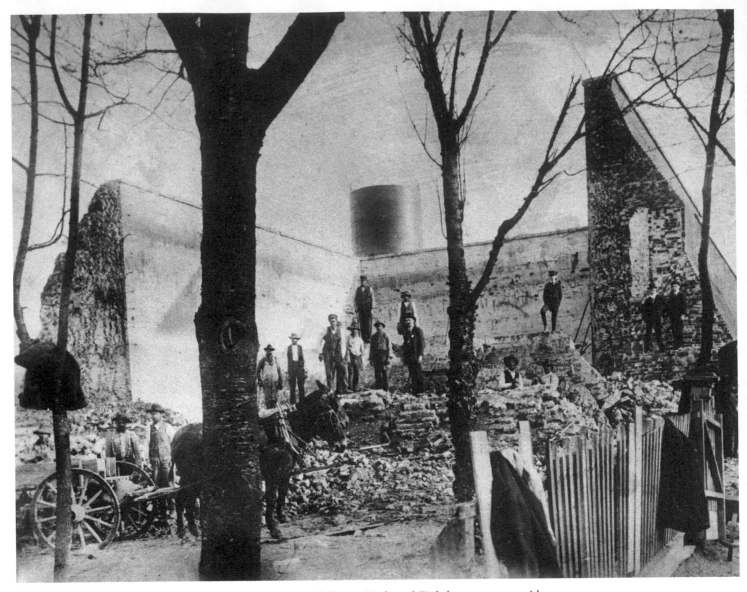

In 1882, Winston built a brick-and-cement reservoir on a hill near Trade and Eighth streets to provide potable water to its citizens. On November 2, 1904, one end of the structure collapsed, and a million gallons of water swept down the hill, destroying everything in its path.

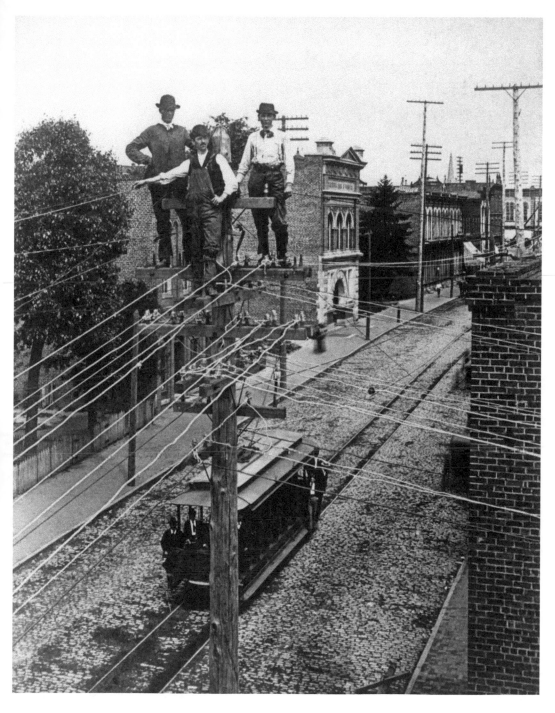

The growth of Winston and Salem can be attributed to industry, but the growth of infrastructure that industry brought to the Twin City created new specializations outside the factories. These city linemen, photographed atop a utility pole around 1904, kept electricity flowing to customers. Trolley tracks are visible below the linemen. By 1904, such tracks lined the center of most thoroughfares throughout Winston and Salem.

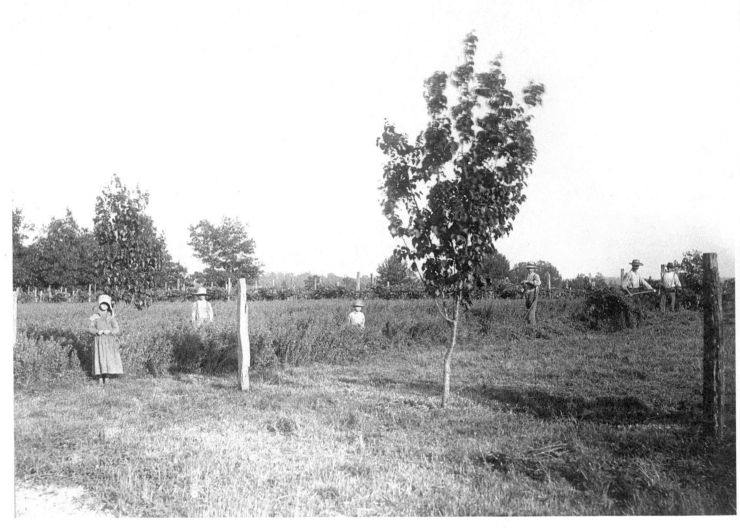

The electricity that brought light to the city flowed less readily into the surrounding countryside. There, family farms predominated and family members labored to pull crops from the soil. Though the yearly tobacco market dominated attention, many farms had truck gardens that provided fresh vegetables to the markets of Winston and Salem from April through November. In this photograph, from around 1904, young and old worked the fields together, perhaps daydreaming of a Saturday trip to town.

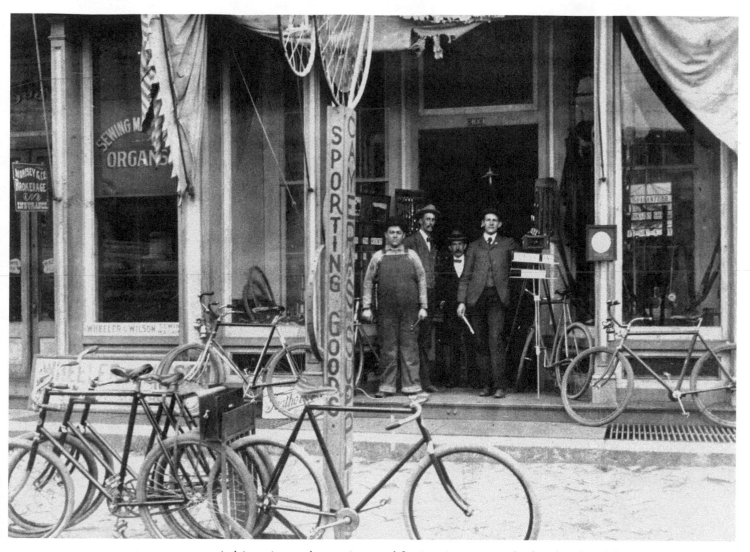

As leisuretime and wages increased for Americans across the first decades of the 1900s, businessmen sought to exploit a new market. Winston's first Golf Club was organized in 1898, and Hege Sporting Goods found good profit in golf and bicycling. Though golf remained a sport for those who could afford it, bicycling became ever more practical as Winston continued to expand its thoroughfares to accommodate a booming population.

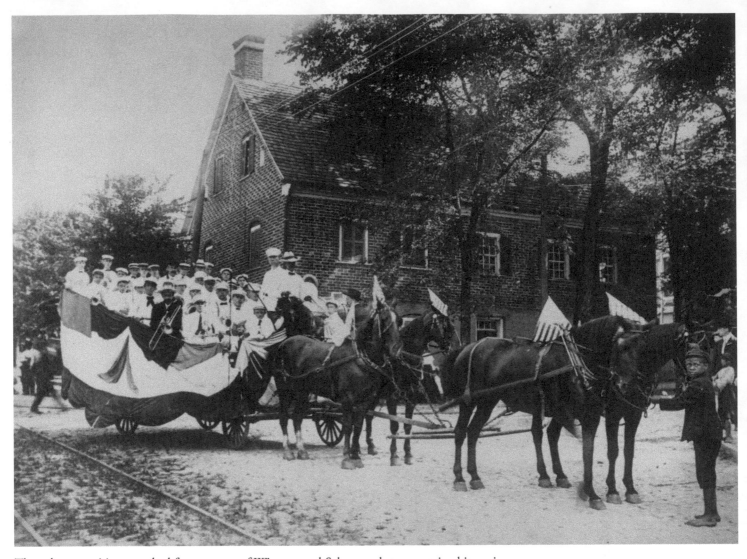

Though many citizens pushed for a merger of Winston and Salem, each town retained its unique identity through the first decade of the 1900s. Here, the Salem Bandwagon participates in a parade around 1905, possibly on Independence Day.

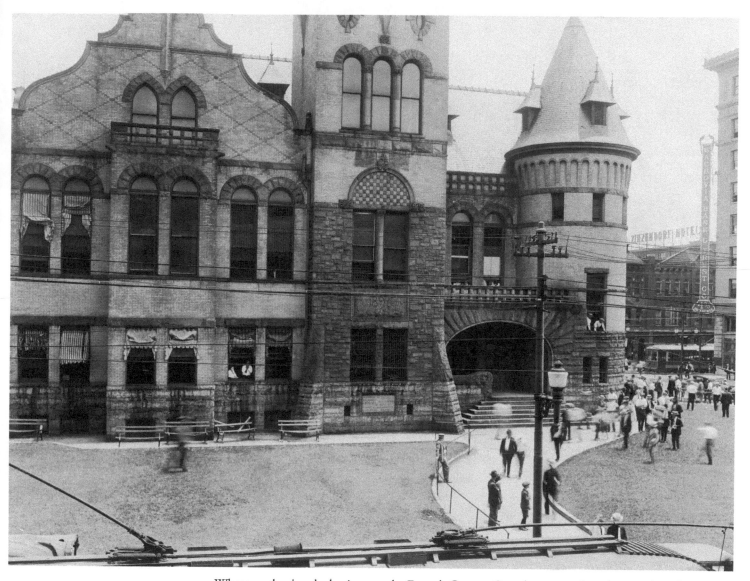

Whatever the decade, business at the Forsyth County Courthouse continued as usual, as depicted in this photograph from around 1907.

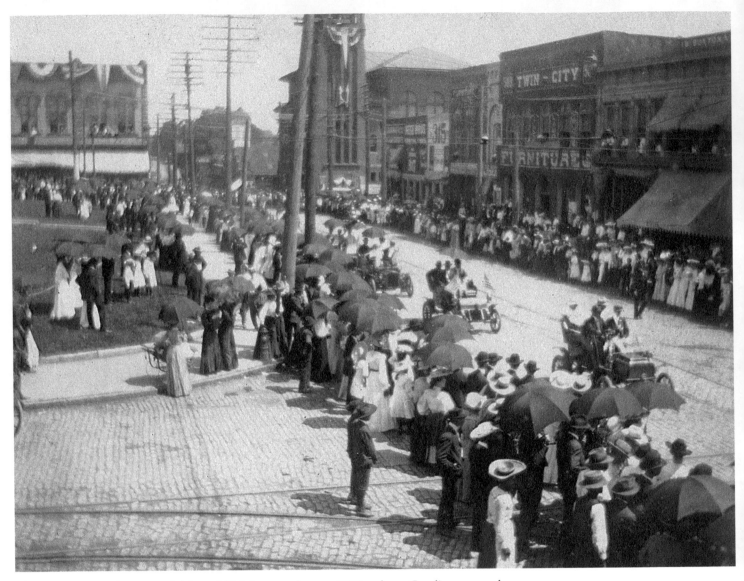

This Winston parade scene at Main and Third streets dates to 1908 or later. Gasoline-powered automobiles, beginning to appear on city streets in numbers in 1908, marked the beginning of a new phase in Winston-Salem's history, though they shared the streets with horses—and horse apples—for years to come.

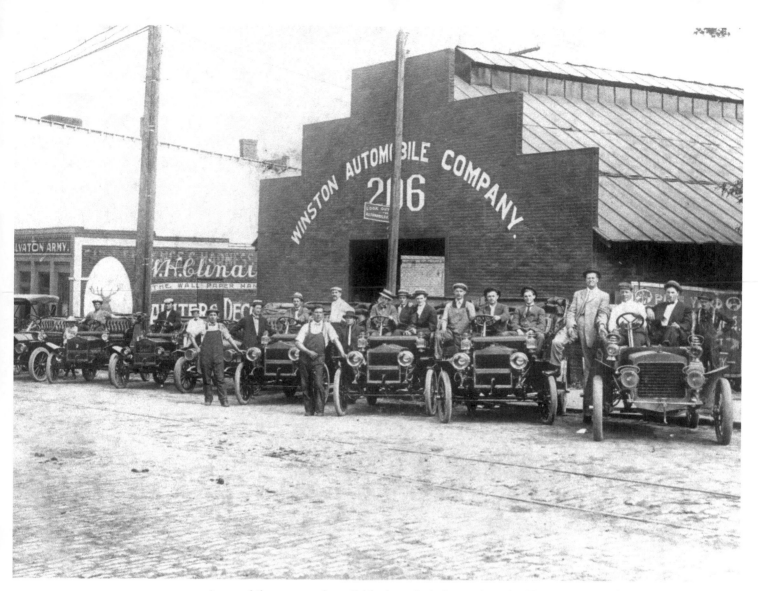

Automobiles were made available through dealers such as the Winston Automobile Company, possibly a sales outlet for the Winston Automobile Company manufacturing firm based in Cleveland, Ohio. Over the next decade, a focus on developing and improving roads required the investment of a substantial portion of Winston-Salem's tax revenue—with near disastrous results in the 1930s.

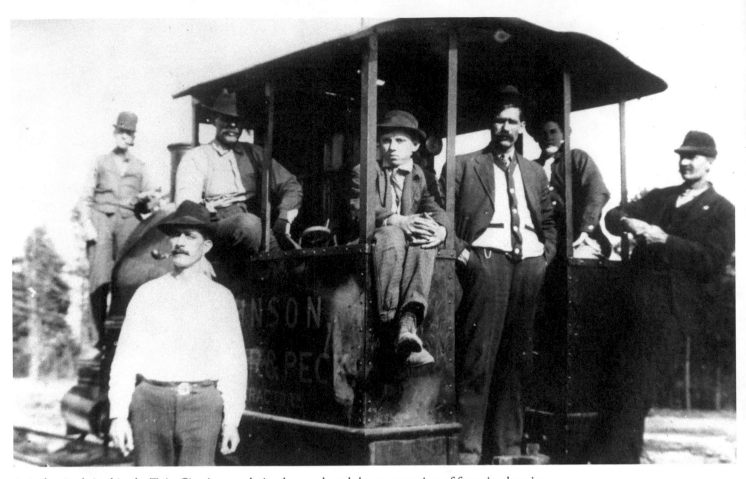

As industry thrived in the Twin City, its population boomed, and the construction of factories, housing, and the infrastructure to support the city was never-ending. Numerous contractors, such as Proctor & Peck, the team pictured here in 1909, found wealth in the growth experienced by Forsyth County.

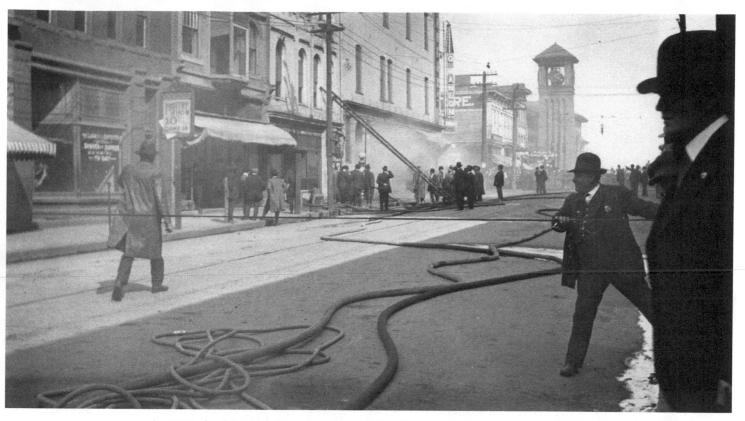

In 1913, the O'Hanlon Drug Store caught fire. Fortunately, the well-trained and well-equipped Winston-Salem Fire Department responded before the fire could jump to other buildings on Fourth Street.

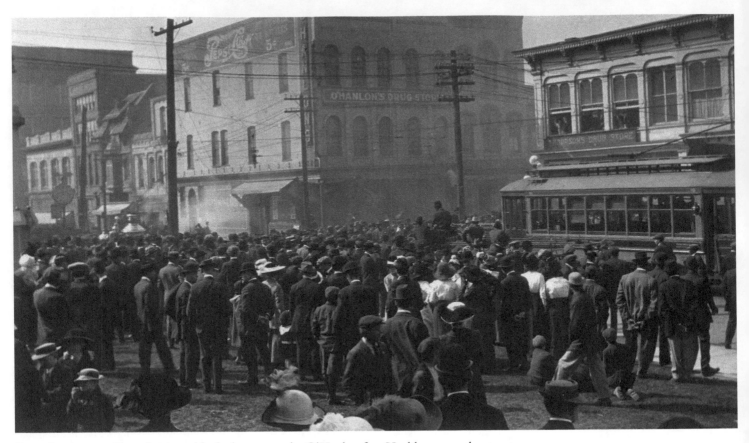

Soon, however, traffic and citizens blocked access to the O'Hanlon fire. Unable to save the structure, firemen sought to control the blaze until additional units could arrive.

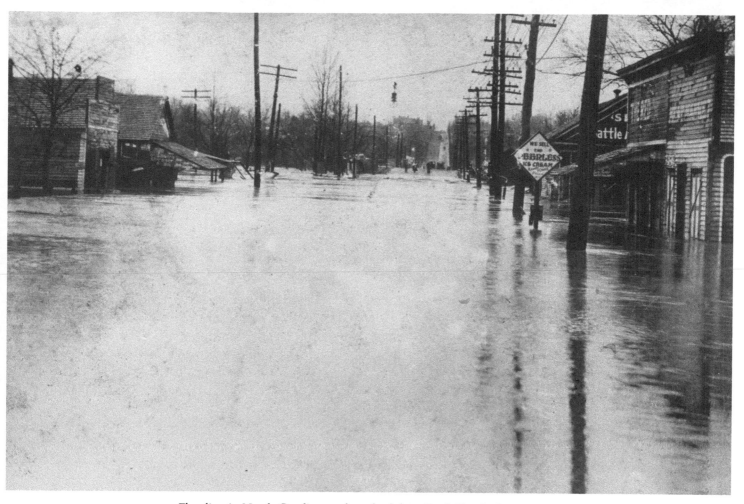

Flooding in North Carolina, such as the Salem Creek Flood of 1912, is not unusual. However, burgeoning metropolises often contributed to local flooding with poor or inadequate planning for expansion.

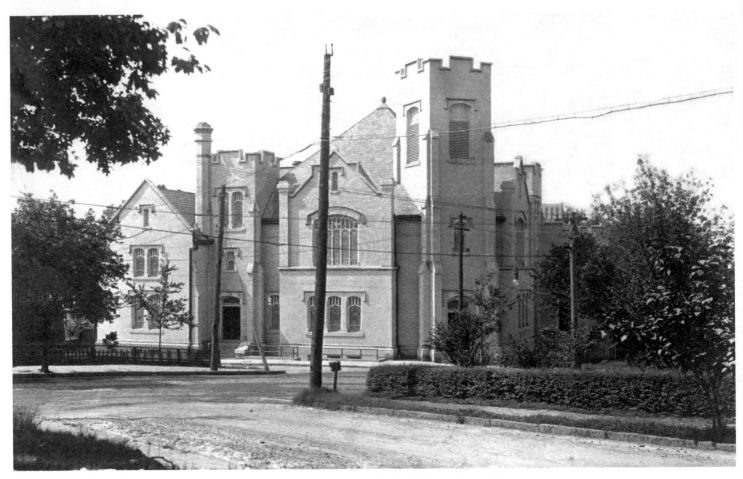

All denominations seemed to flourish in Winston-Salem, and many of the buildings reflected the wealth pouring into the region in the early 1900s. The beautiful architecture of West End Methodist Episcopal Church, photographed in 1913, is one example.

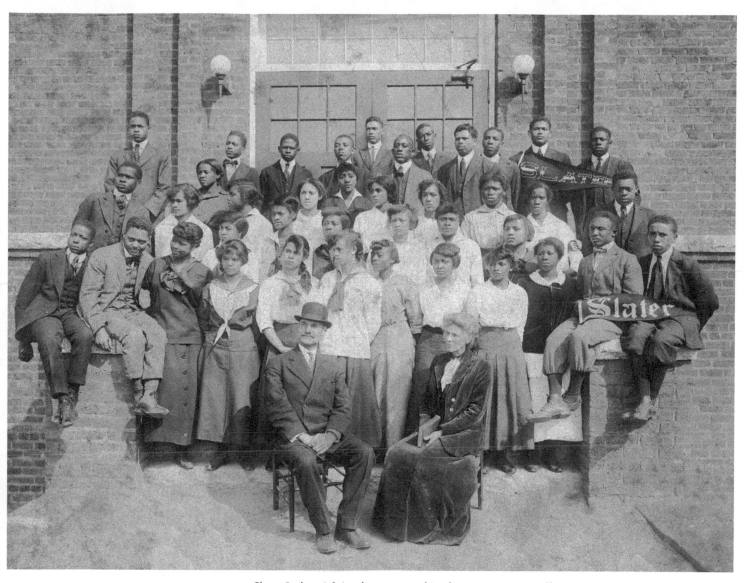

Slater Industrial Academy opened its doors in 1892 to offer continuing education to African Americans in segregated Winston-Salem. Over the years, it graduated many fine students, such as these pictured in 1915 with Simon Greene Atkins, the founder of the institution. In 1969, the college became Winston-Salem State University.

If your favorite star was not showing at the Amuzu Theater, you could try here, the Pilot Theater, a few blocks away.

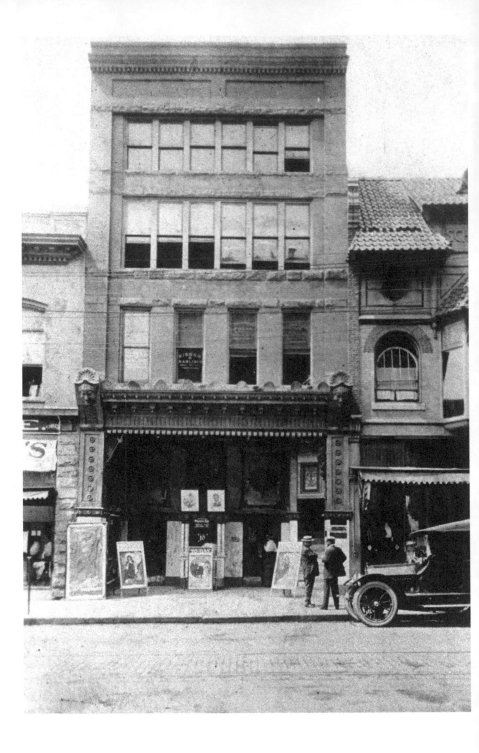

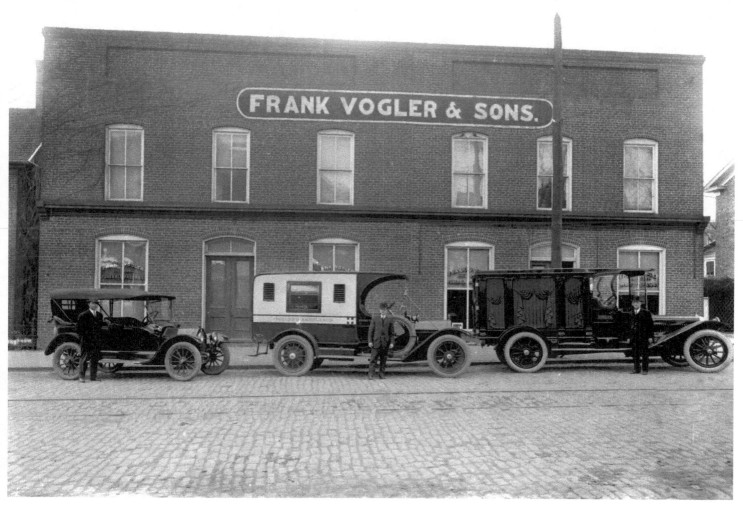

From 1858, Frank Vogler & Sons served as the premier undertakers, then funeral home, in Salem and Winston-Salem. A state-of-the-art hearse is parked in front of their business around 1918.

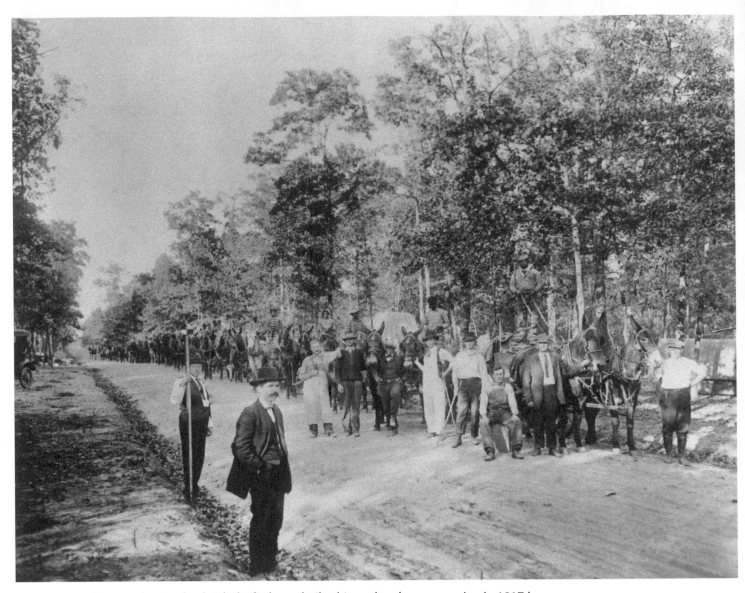

Like so many things in the city that bright leaf tobacco built, this road under construction in 1917 is named after R. J. Reynolds, or at least after his new estate, Reynolda, completed that same year.

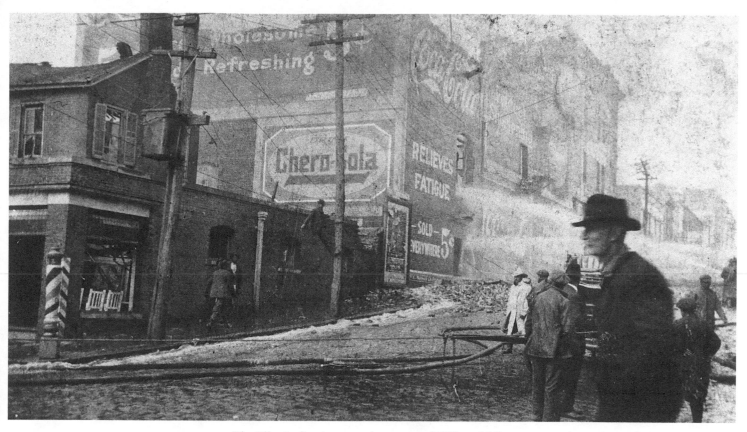

The Elks Auditorium, on the corner of Fifth and Liberty streets, burned in 1916. The 1,800-seat State Auditorium opened in the same location the following year. It would remain the area's largest performance hall until the opening of R. J. Reynolds Auditorium in 1924.

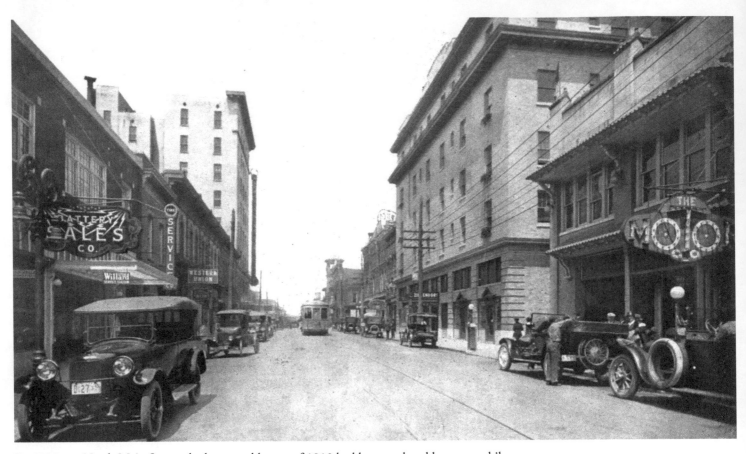

By 1918, on North Main Street, the horse and buggy of 1910 had been replaced by automobiles.
The electric trolley remained—for another generation.

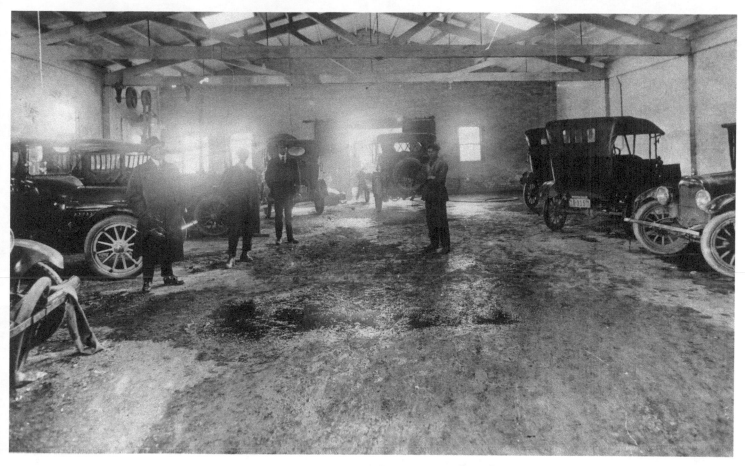

By 1918, a number of garages existed in downtown Winston-Salem.

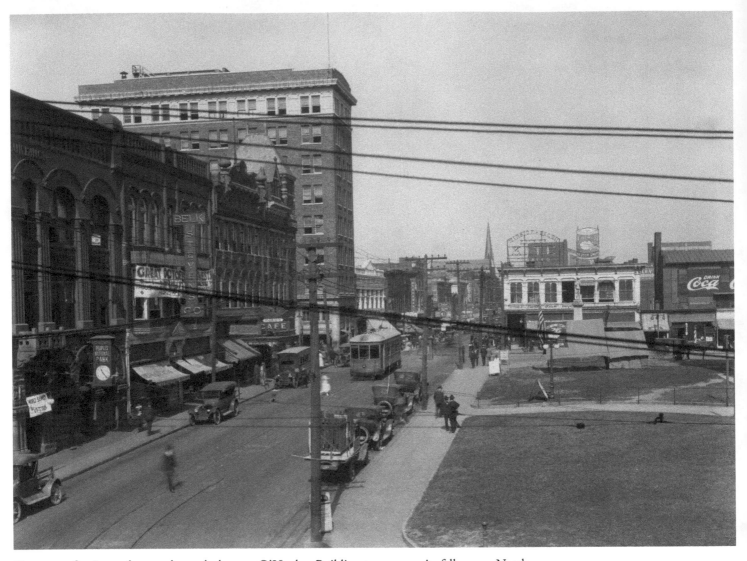

Five years after its predecessor burned, the new O'Hanlon Building towers over its fellows on North Liberty Street.

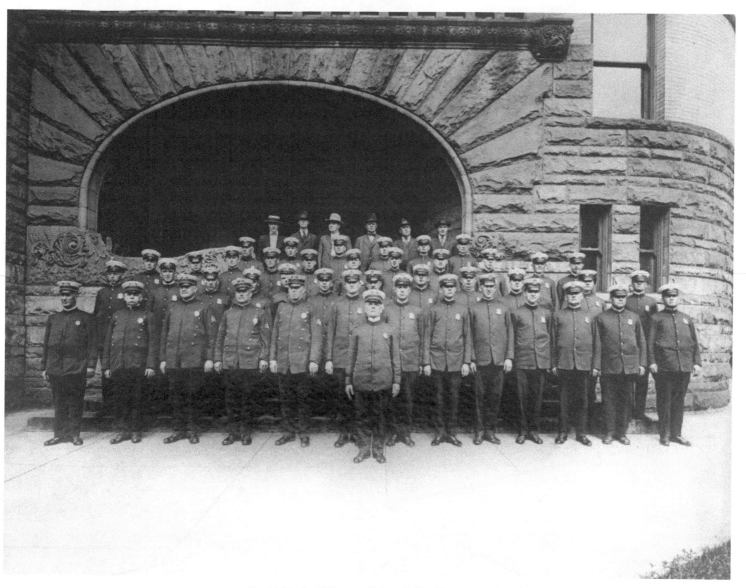

By 1898, the Winston-Salem Police Force, standing here in front of the new Forsyth County Courthouse, was as professional as any such force in the South—and snappy dressers as well!

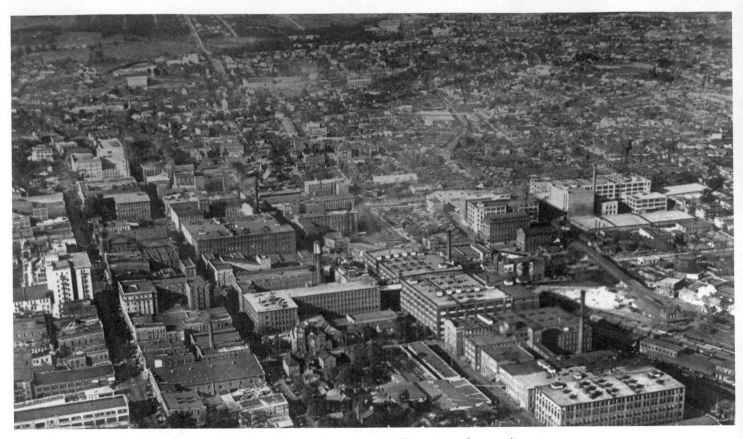

One of the earliest aerial photographs of Winston-Salem, taken in 1923, offers a view of a sprawling city replete with skyscrapers and massive factories. Winston-Salem stands ready as the Roaring Twenties commence.

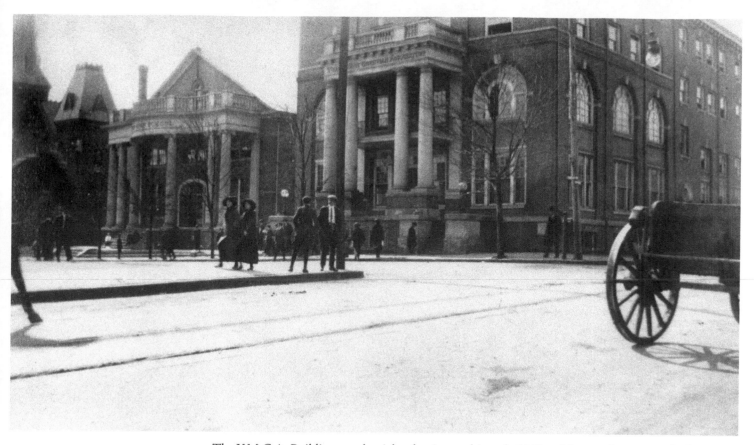

The Y.M.C.A. Building, on the right, dominates this early 1920s tableau at the corner of Cherry and Fourth streets. The First Presbyterian Church stands at far left, and the center building is Winston High School, which would be destroyed by fire in 1923.

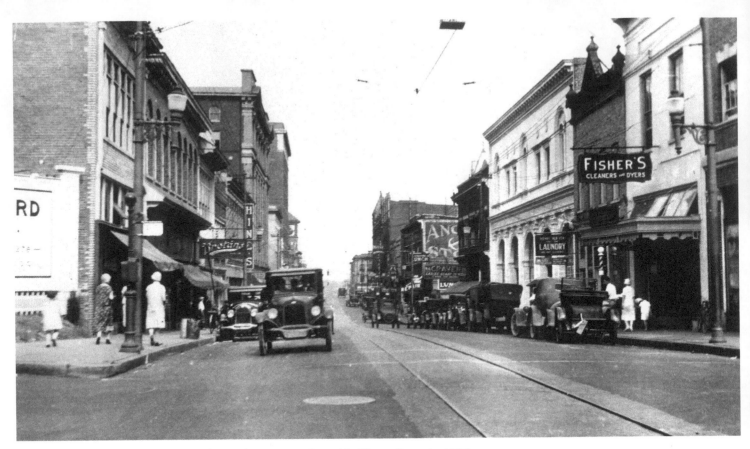

Automobiles line West Fourth Street beyond its intersection with Cherry Street in 1925.

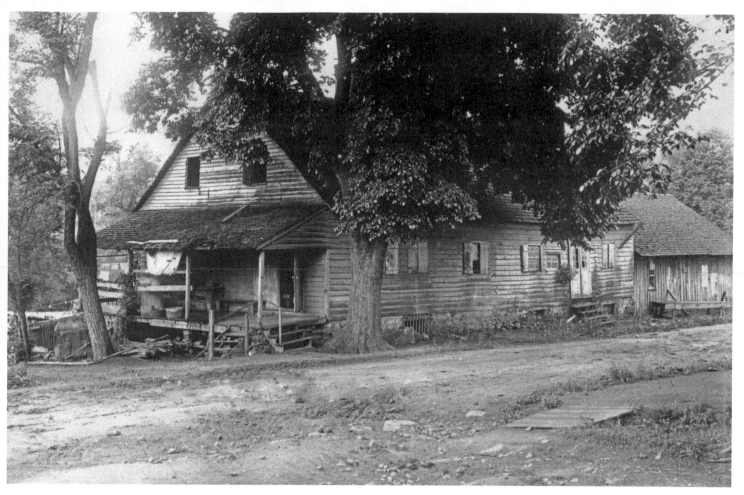

Sometime after 1920, the decaying Salem Brewery and Tan Yard stood silent, as did even more modern breweries, victims of Prohibition.

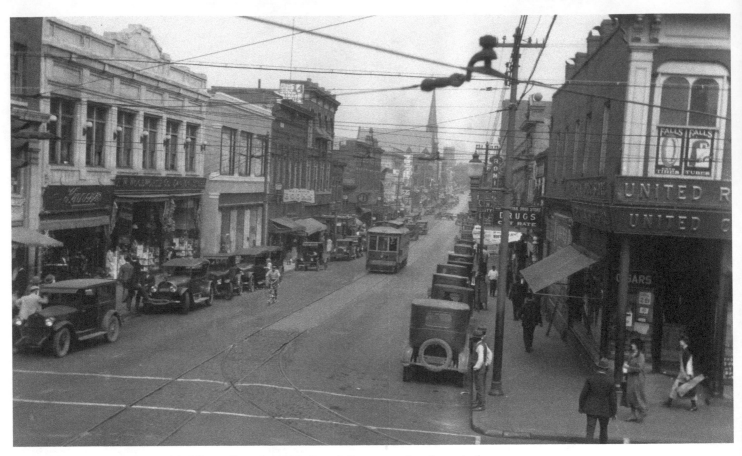

Viewed from its intersection with Liberty Street in 1925, Fourth Street reveals a dynamic downtown in Winston-Salem. People visit the bank or shop at department and specialty stores, or at the F. W. Woolworth store on the left, while their new cars lining the street reveal a level of prosperity enjoyed by few towns in North Carolina.

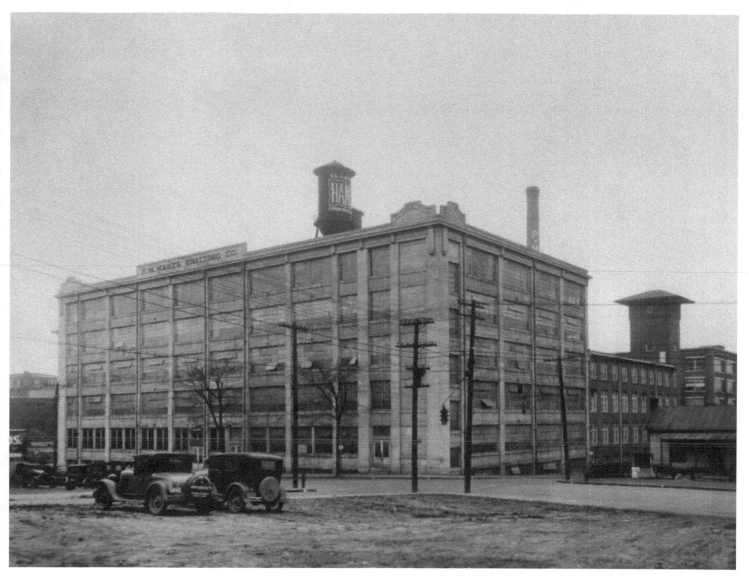

In the 1920s, the long-standing Hanes Knitting Company remained a vigorous Winston-Salem industry. By 1920, it had a new factory at Sixth and Main streets, as well as a cotton mill and a spinning mill, both located in Hane, the village the company built for its employees on the edge of Winston-Salem.

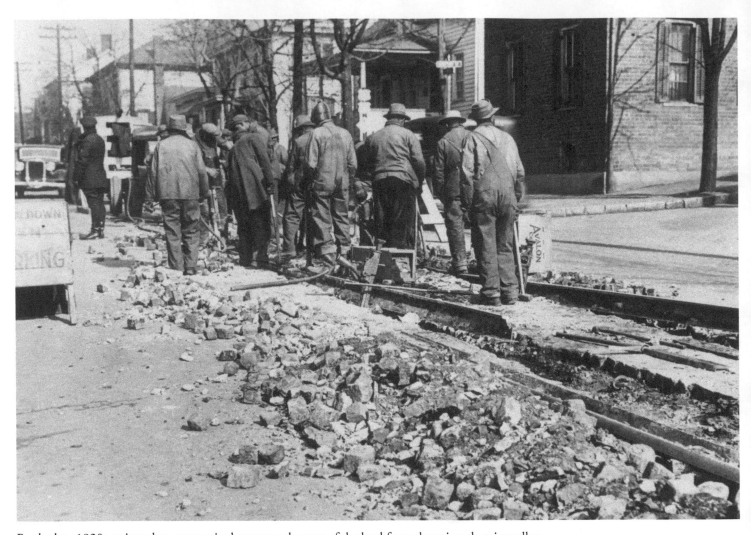

By the late 1920s, private bus companies began to take part of the load from the aging electric-trolley fleet. In this photograph, workmen repair or perhaps remove old trolley rails from the center of a Winston-Salem street.

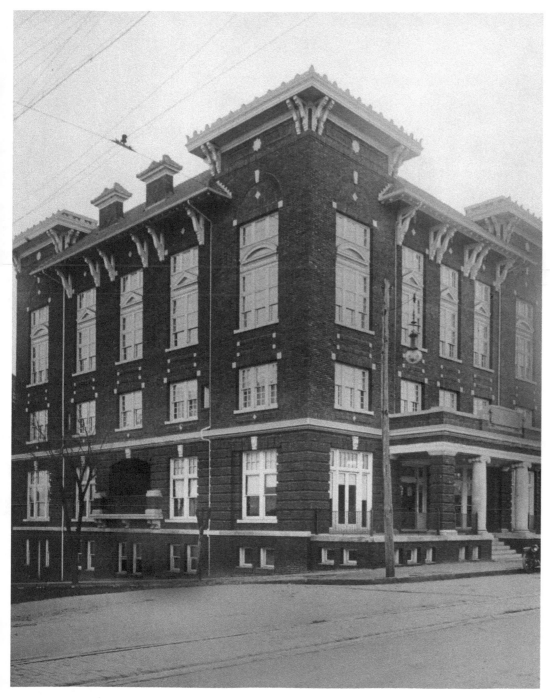

Built in 1885, the Twin City Club thrived throughout the 1920s. Its dances, frequently held for teenagers, offered excellent opportunities to meet that special someone in chaperoned circumstances. The New Year's Eve and Easter Monday dances were the social equivalent of "coming out" dances for local debutantes.

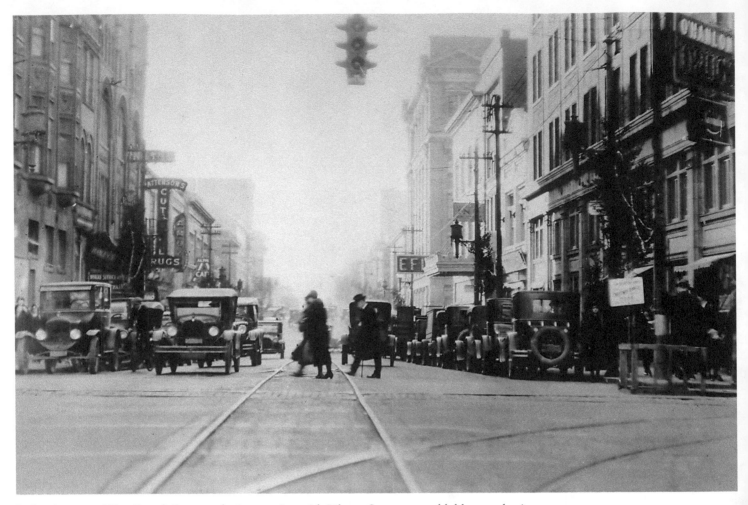

Pedestrians cross West Fourth Street at the intersection with Liberty Street on a cold, blustery day in the late 1920s. A traffic light is visible at top-center of the photograph—a sure sign of increasing traffic in the city.

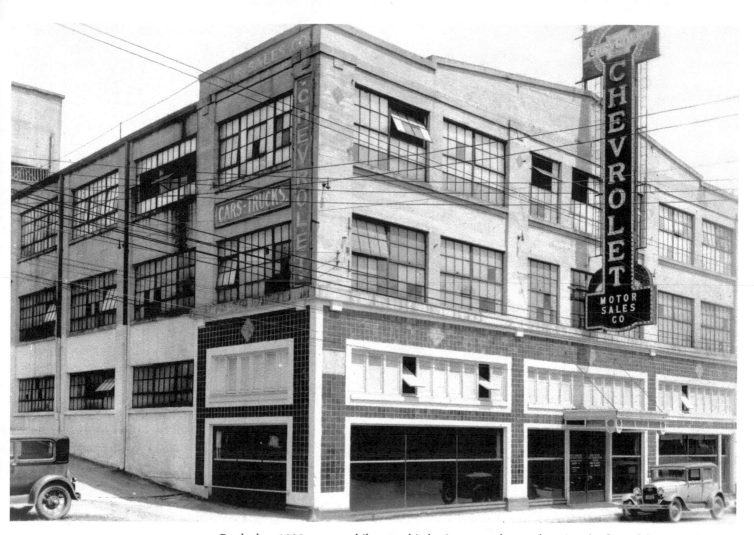

By the late 1920s, automobiles were big business—and were changing the face of the United States. Chevrolet Motor Sales Company was only one of many car dealerships that also offered automotive service to its customers.

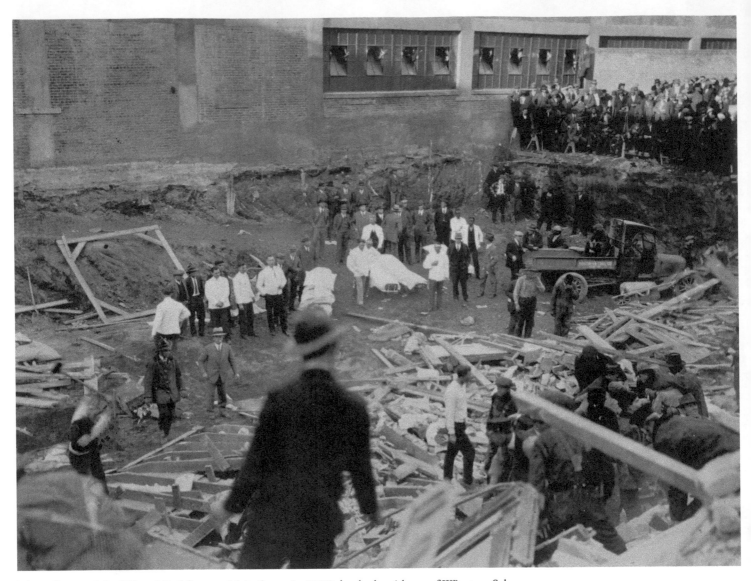

The collapse of the Urband Building on Main Street in 1927 shocked residents of Winston-Salem.

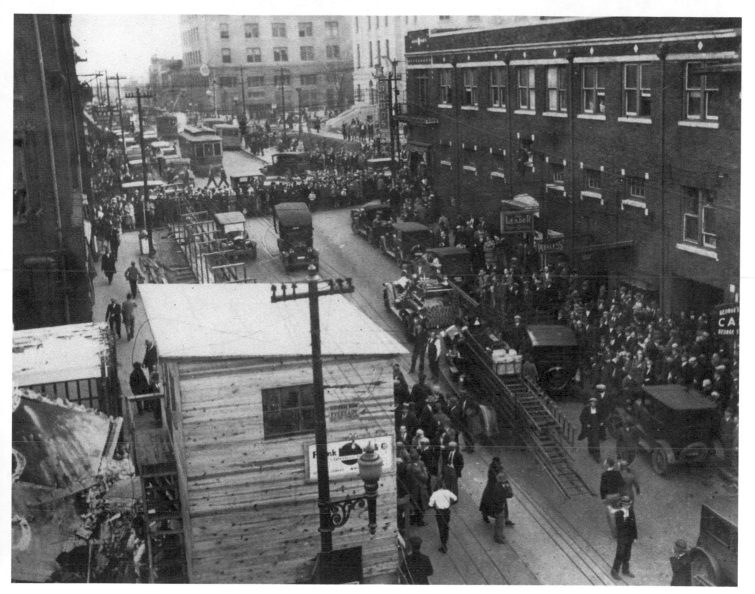

Citizens rush to assist after the collapse of the Urband Building.

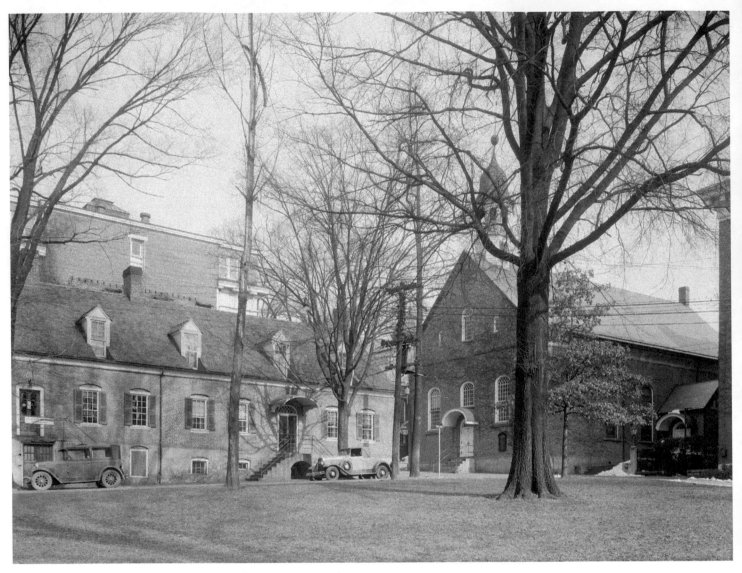

Buildings at Salem College are seen across Salem Square around 1927.

THE HARD TIMES

(1930–1949)

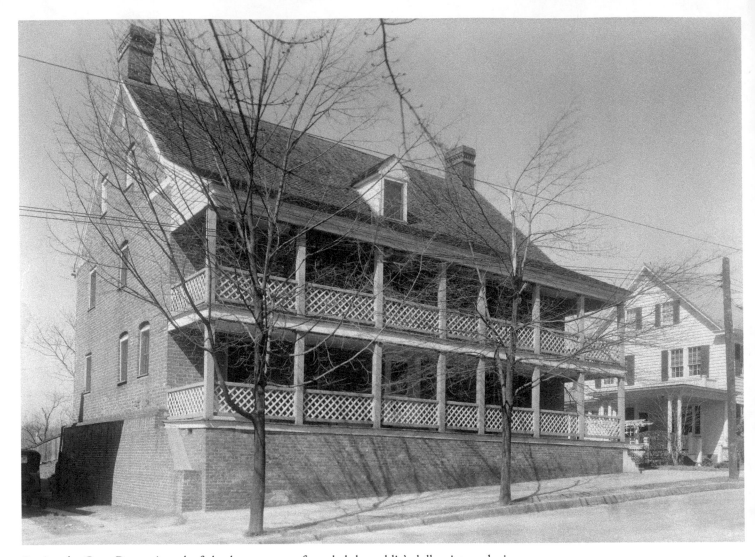

During the Great Depression, the federal government funneled the public's dollars into reducing unemployment, including hiring people to document American historical and cultural artifacts. Photographers participating in the Historical American Buildings Survey (which began in 1933) captured many Winston-Salem historic sites on film, such as Salem Tavern on South Main Street, dating from 1784 and photographed in 1934. There George Washington once enjoyed a peaceful evening, and probably a dram or two.

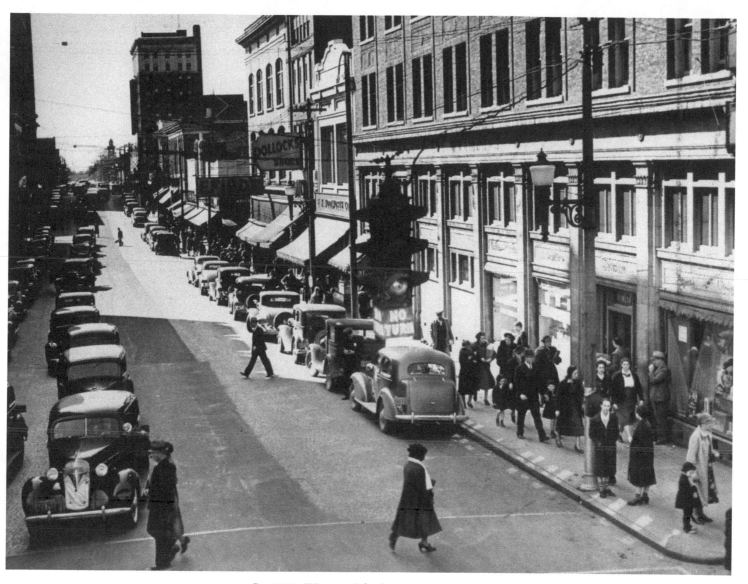

By 1935, Winston-Salem's economy seemed to begin to recover from the worst effects of the depression. The Federal Reserve Board rated it as one of the top ten cities in the country in industrial production, while aggressive programs such as clean-up campaigns and job-sharing kept at least some money in most pockets. This view along West Fourth from Liberty Street seems little different from the busy streets of the late 1920s.

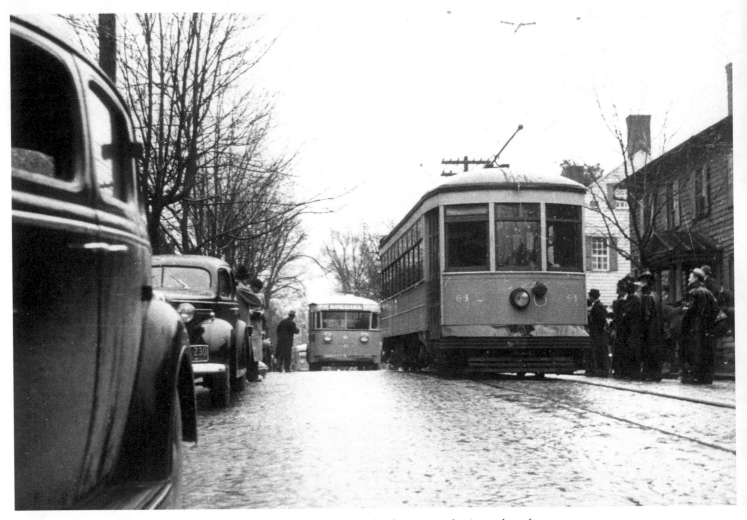

A new city bus passes an old streetcar in 1936. The streetcar seems to be doing more business than the bus; however, by the end of the year the old electric trolleys would go the way of the horse and buggy in Winston-Salem, another casualty of the internal combustion engine.

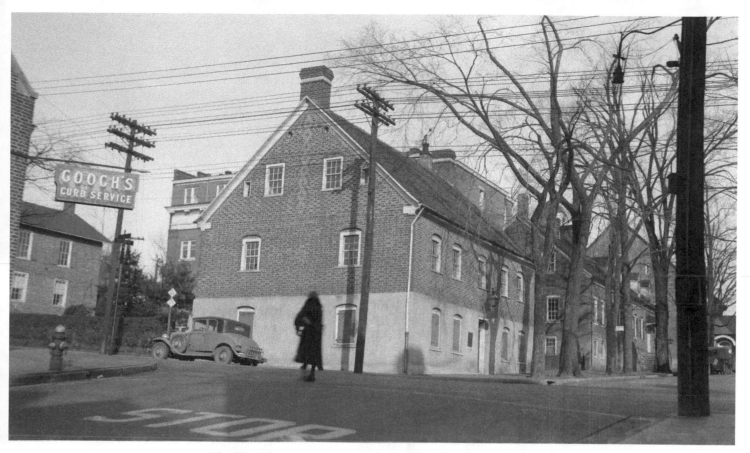

The Moravian community constructed the Salem Boys School at Main and Academy streets in 1794. This photograph, from 1934, does not show the Hall of History added to the structure in 1937 by the Wachovia Historical Society. Formed in 1895, the society's work to preserve the treasures of Old Salem is praiseworthy.

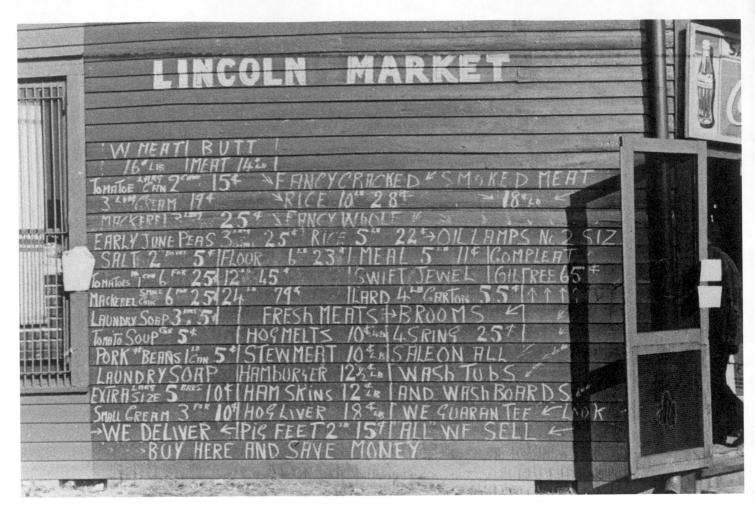

Typical of many corner grocery stores trying to survive in Winston-Salem in 1935, the Lincoln Market carried a variety of goods, from laundry soap to meats, at reasonable prices—reasonable, that is, for those who had money. The market's outdoor advertising caught the eye of famed photographer Walker Evans, who was working for the U.S. Resettlement Administration (predecessor of the Farm Security Administration) when he took this photograph.

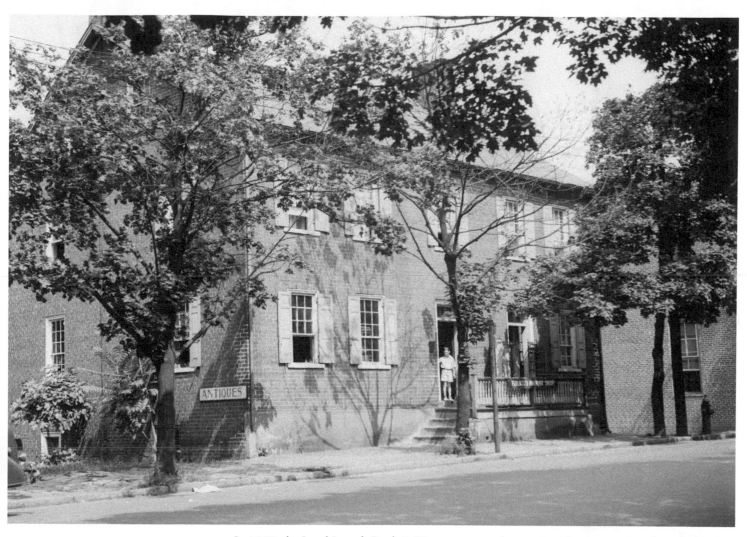

In 1937, the Israel Loesch Bank & House supported an antique business rather than the lending institution of the 1790s. The building is on South Main Street.

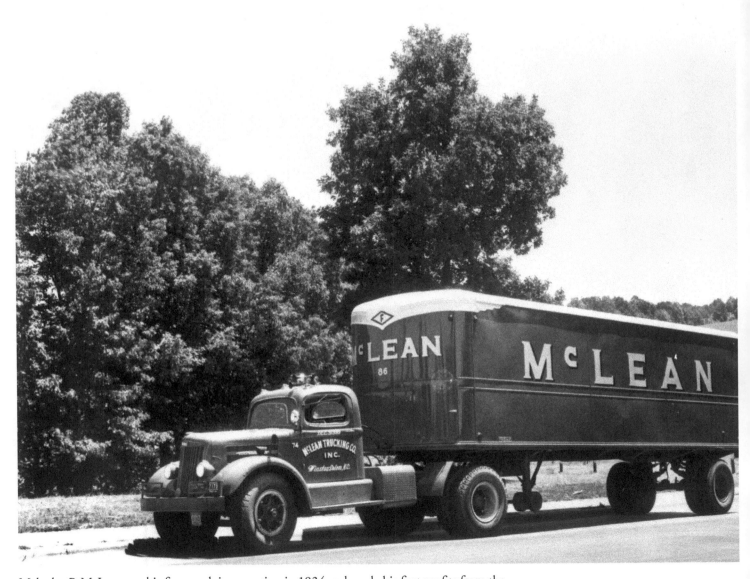

Malcolm P. McLean put his first truck in operation in 1934 and made his first profits from the fledgling business hauling empty tobacco barrels around Winston-Salem. In 1943, McLean Trucking established its headquarters in the city, the first of more than 40 trucking firms that would do so. Winston-Salem became a transportation center, and Malcolm McLean later achieved fame for his development of the concept of containerization.

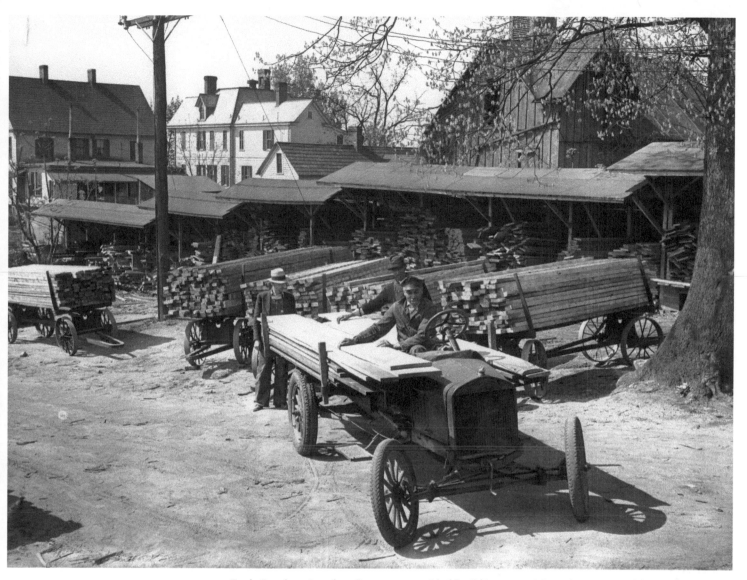

Fogle Brothers Lumber Company provided building materials and constructed homes in Forsyth County beginning in the 1800s. Sustained by assets and a name for dependability acquired during the Winston-Salem building boom and growth of 1900–1929, Fogle Brothers survived the Great Depression, as is evident by the activity visible here in 1938.

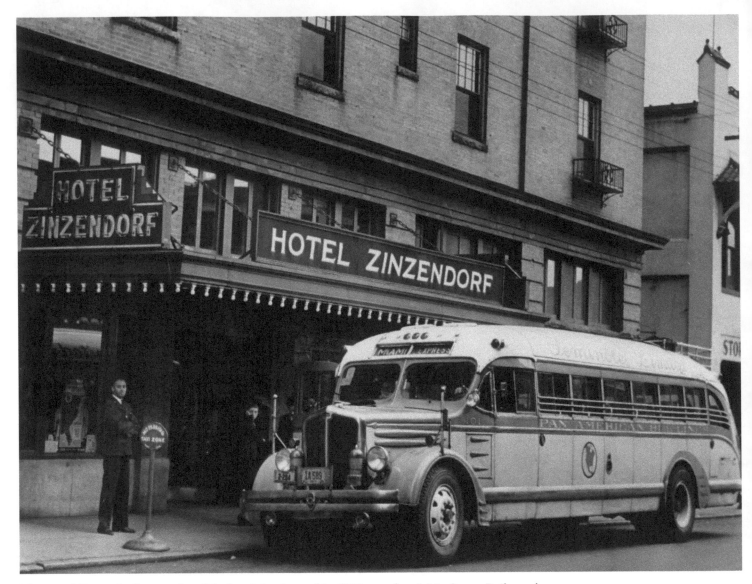

The Hotel Zinzendorf, namesake of the hotel that burned in 1892, stood on Main Street. Built on the site of the old Hotel Jones in 1906, the Zinzendorf featured 120 rooms, each with a telephone. Thirty rooms even had private baths with hot water. By 1938, when this city bus stopped in front, the hotel seemed dingy and worn, as did most of downtown Winston-Salem. Demolished in 1970, the hotel made way for the Federal Building, which now occupies the site.

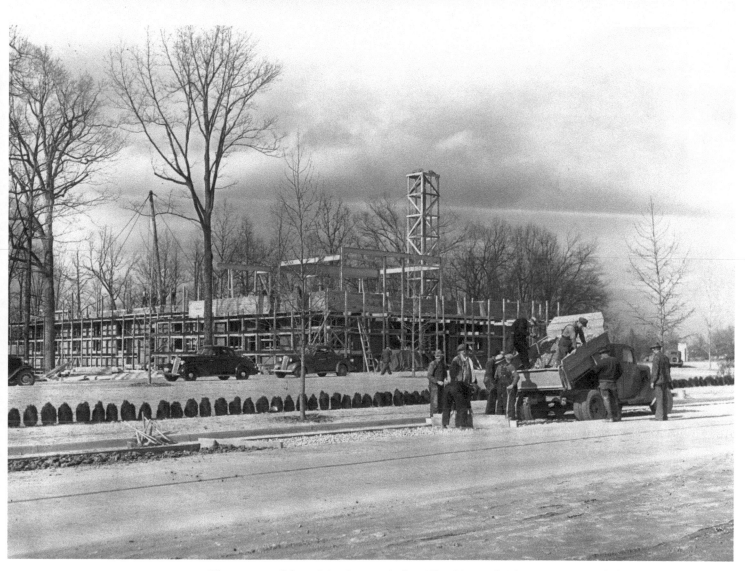

The owners of three dairy farms—Arden, Klondike, and Whit-Acres—joined their capital in 1937 to build Selected Dairies on South Stratford Road. The company would eventually draw on at least six local farms for raw milk. New industry meant jobs, not only for plant workers but also for these men working to complete construction of Selected Dairies in 1938.

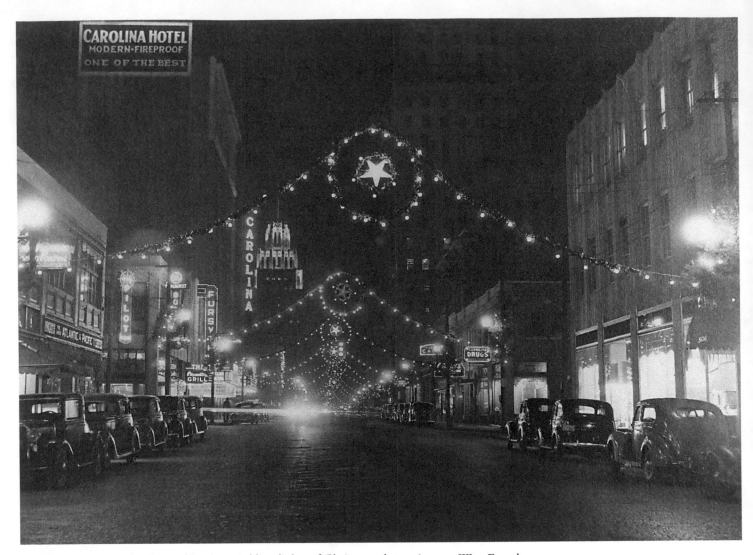

By Christmas 1938, the future, like the twinkling lights of Christmas decorations on West Fourth
Street, probably seemed a little brighter to residents of Winston-Salem. Though some shop fronts
may have been empty, the Carolina Theater still attracted patrons, the Carolina Hotel still expected a
Christmas rush, and the lights of the Reynolds Building, a symbol of industrial might, still glowed in
the night.

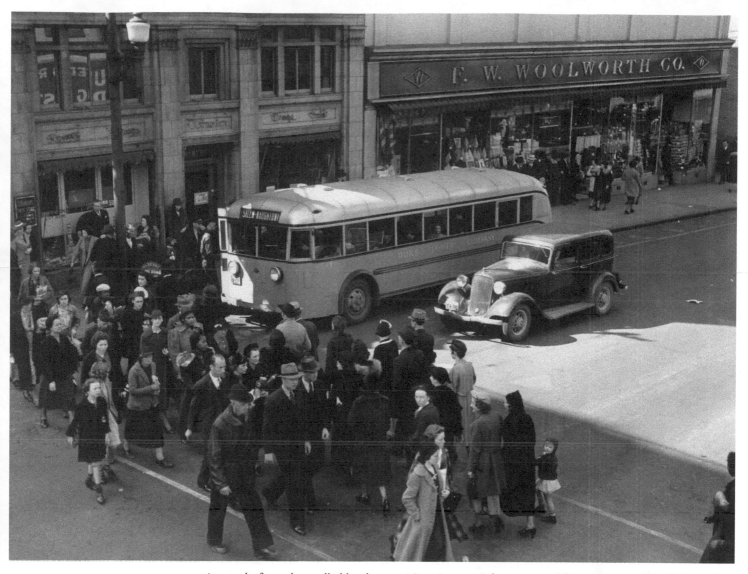

A crowd of people, swelled by the emptying city transit bus, crosses Liberty Street at Fourth Street late in 1938. Perhaps off to work, or maybe headed for some early morning shopping, some would cross the street again at noon to visit the lunch counter at the Woolworth store.

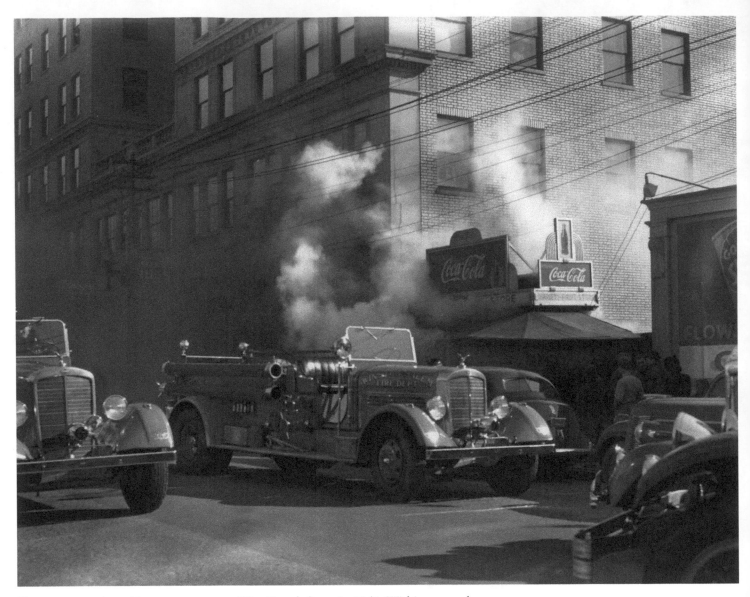

Firemen respond to a blaze at an eatery on West Fourth Street in 1940. Within a year, the average age of firemen would increase dramatically. Many of the nation's young men would either volunteer or be drafted into the military to defend the nation during World War II.

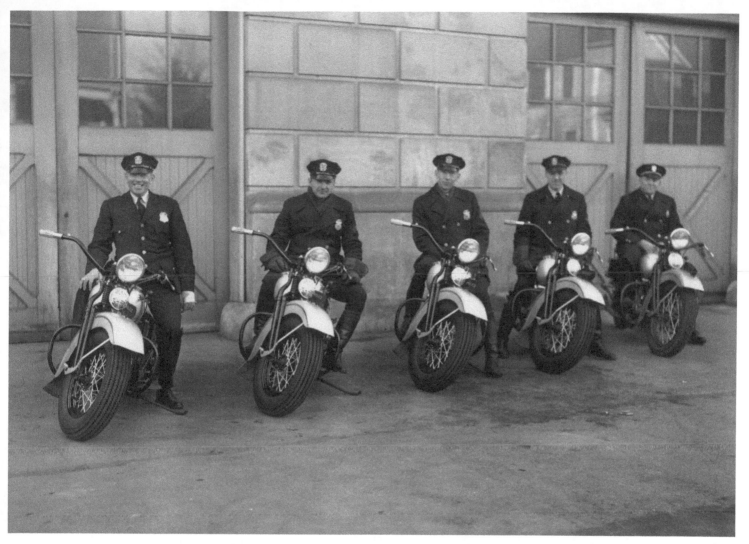

Adopted by the police forces of many towns during the Great Depression, motorcycles proved cost-effective and highly maneuverable in urban settings. These Winston-Salem officers pose for a group shot in 1940.

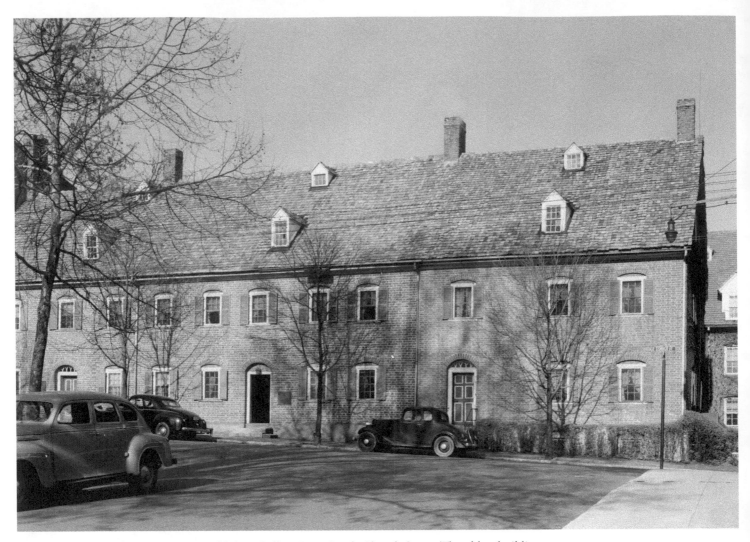

Seen here in 1940, the Sisters House of Salem College is on South Church Street. The oldest building on the Salem College campus, the Single Sisters House dates to 1785, with additions in 1819. The unmarried women of the Moravian community operated a school for young women inside this building, making it extremely important to the history of women's educational rights in America.

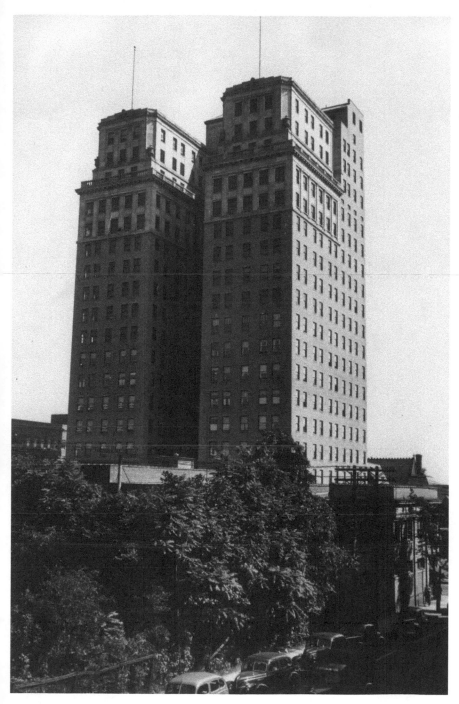

Built in 1927 on the corner of North Cherry and West Fourth streets, the Nissen Building, seen here in 1940, stood 20 stories tall. The family of W. M. Nissen, owner of Nissen Wagons (founded in 1787), lived on the top floor and leased space on the floors below. This was the first air-conditioned building in the Southeast and leasing went well. Recently, the building has been converted into a gorgeous apartment complex.

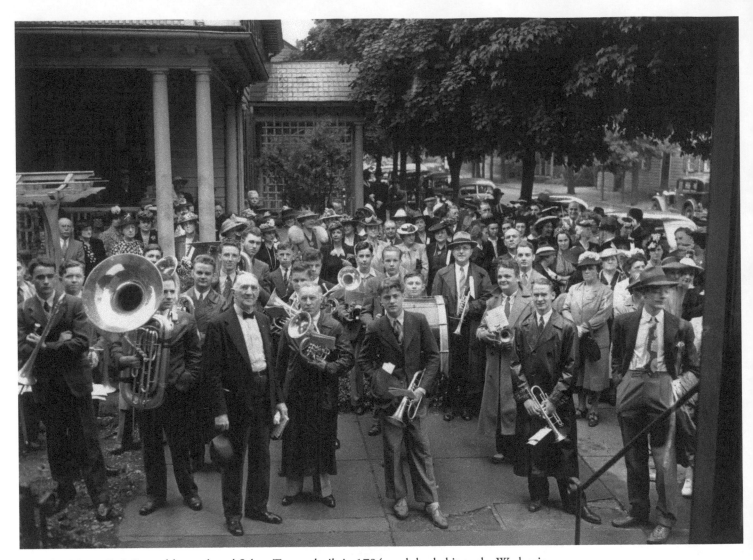

In 1941, Mayor R. J. Reynolds purchased Salem Tavern, built in 1784, and deeded it to the Wachovia Historical Society, which had been struggling to save the building from commercial developers. A dedication ceremony coincided with the 175th anniversary of Winston-Salem (the Moravians founded Salem in 1766). Short months later, an anonymous member of the WHS would write an "Inventory of Specimens in Wachovia Museum to be Moved to Place of Safety in Case of Attack."

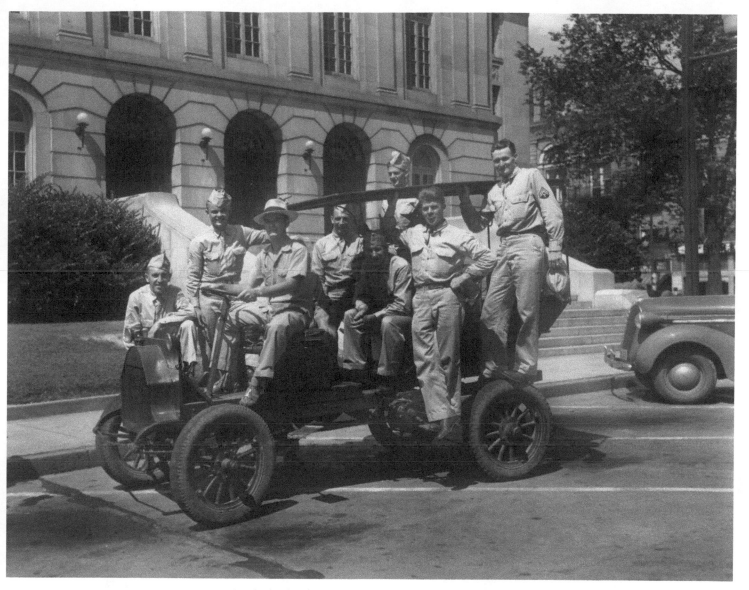

On the heels of the Great Depression, World War II called upon Winston-Salem to contribute to the war effort. The *Winston-Salem Journal* lost 55 employees to the military by 1942; area industries parted with hundreds of workers. In this photograph, snapped sometime during 1941 or 1942, soldiers pose in front of the courthouse.

This "barometer" outside the county courthouse measured the money donated to build Memorial Coliseum, part and parcel of the wooing of Wake Forest College to Winston-Salem. The money was collected, and in 1955, the thudding of basketballs began to echo inside the new structure. Memorial Coliseum, with seating for 8,500, remained home court for the Demon Deacons until replaced by Joel Coliseum in 1989.

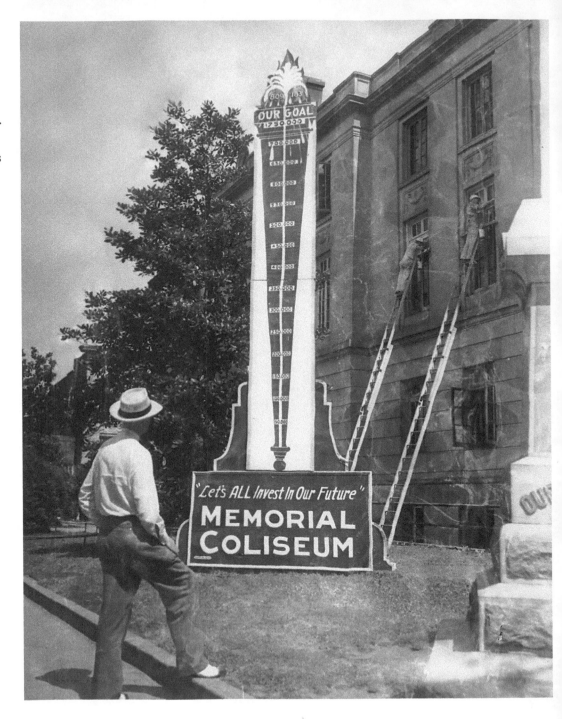

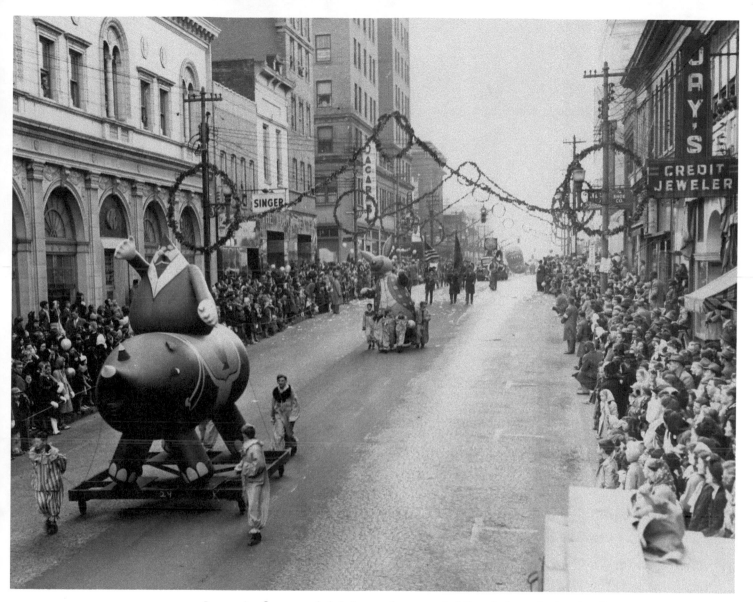

Impressive floats wended their way along crowded Fourth Street during the Christmas parade of 1947. New Christmas decorations for the city echoed a new attitude for the city. World War II had ended, most of the boys were home, and the first stirrings of the cold war to come were hardly noticed.

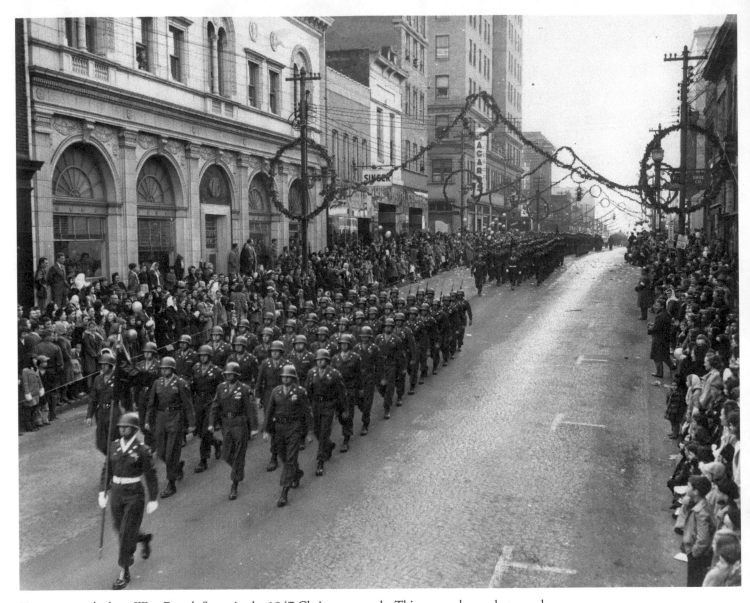

Veterans march along West Fourth Street in the 1947 Christmas parade. This was perhaps a last march in uniform for some, as they prepared to return to civilian life after serving the nation overseas during the war.

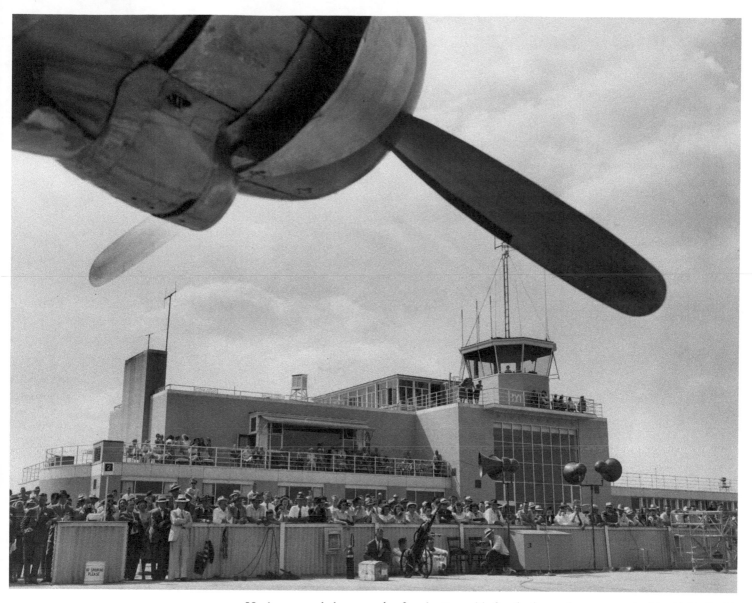

Having expanded constantly after the Reynolds family donated a new terminal in 1942, Smith Reynolds Airport—named for the lost son of the family, Z. Smith Reynolds—stood second to none in North Carolina in 1947. In fact, Eastern Airlines representatives believed this was the finest terminal in the United States.

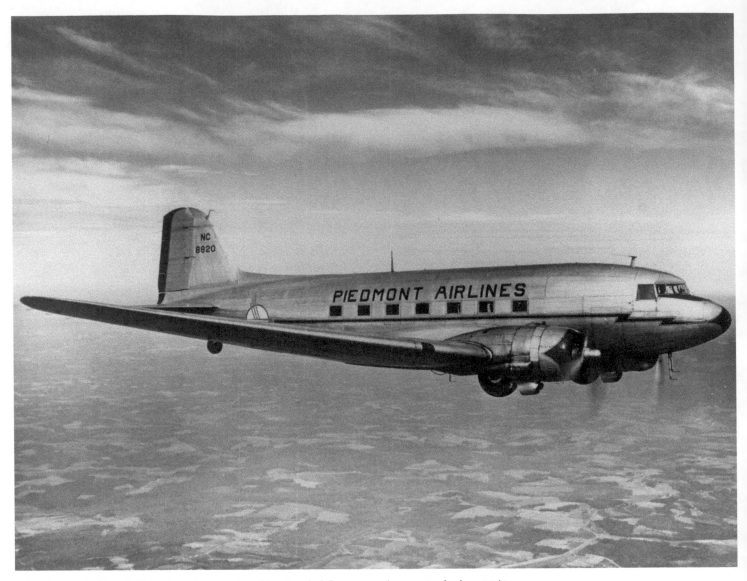

A Piedmont Airlines DC-3 wings through the skies, headed for parts unknown in the late 1940s. Based in Winston-Salem, the airline made its first commercial flight in 1948, flying (with stops) from Wilmington, North Carolina, to Cincinnati, Ohio, two of the 22 cities Piedmont served that year while transporting around 40,000 passengers.

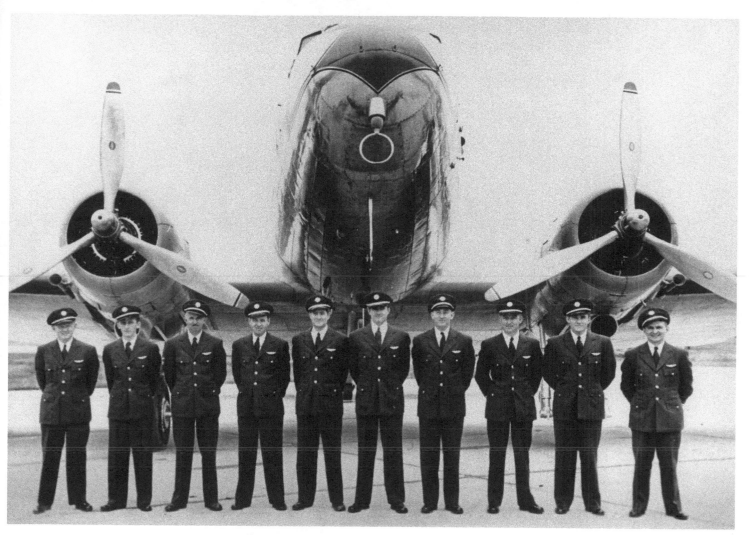

The first Piedmont Airlines pilots stand in front of a DC-3 at Smith Reynolds Airport in 1948. Winston-Salem would remain the headquarters of Piedmont until 1987, when US Air purchased the airline.

Salem College alumnae meet in May 1948 to dedicate Alumnae Hall, the new building their generosity purchased for the school.

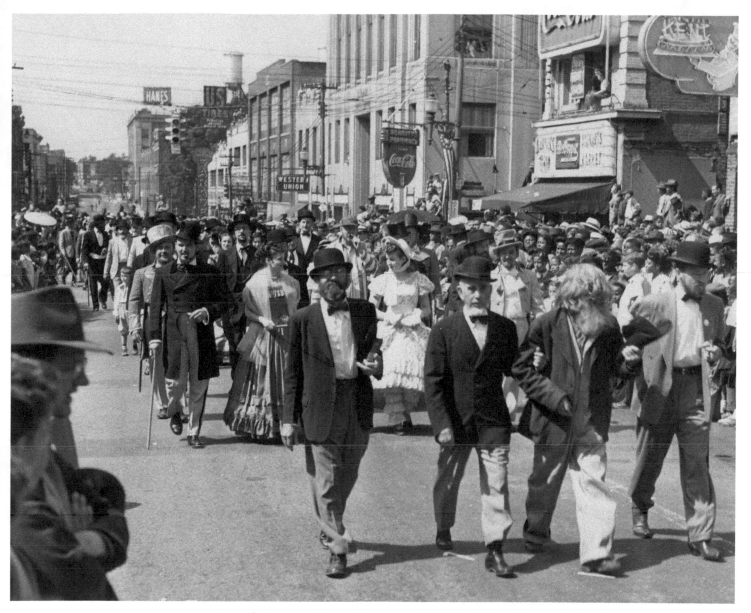

Forsyth County celebrated its centennial in May 1949 with a parade that featured period costumes.

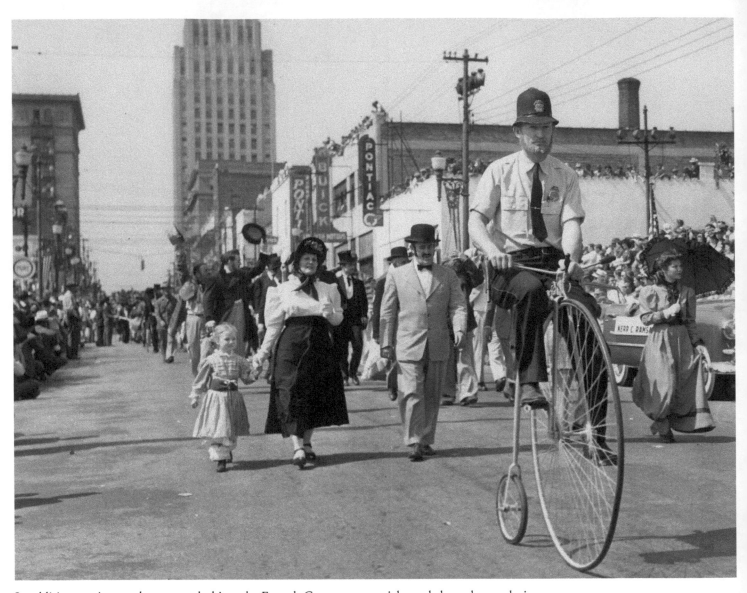

In addition to nineteenth-century clothing, the Forsyth County centennial parade brought out devices such as this vintage penny-farthing bicycle.

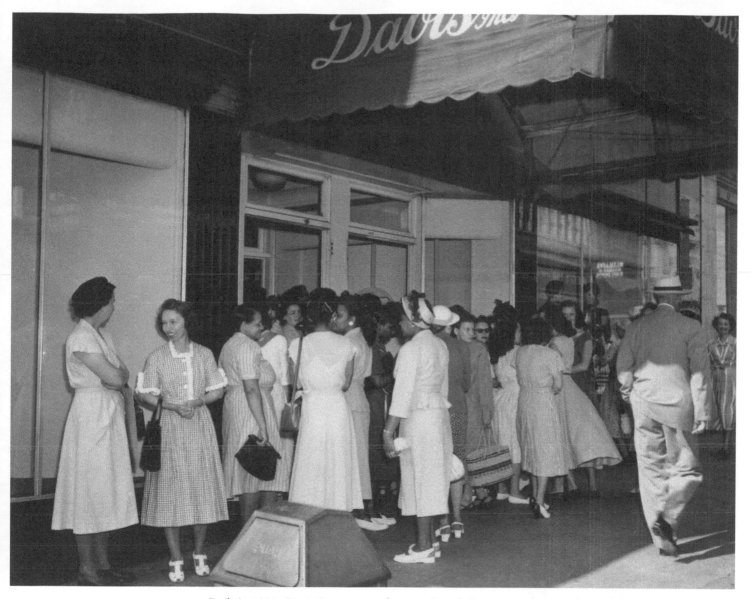

Built in 1910, Davis Department Store on Fourth Street served generations of shoppers, such as these ladies waiting for the doors to open and a sale to begin in 1948. In 2008, the city was discussing razing the building for new construction in an attempt to revitalize downtown.

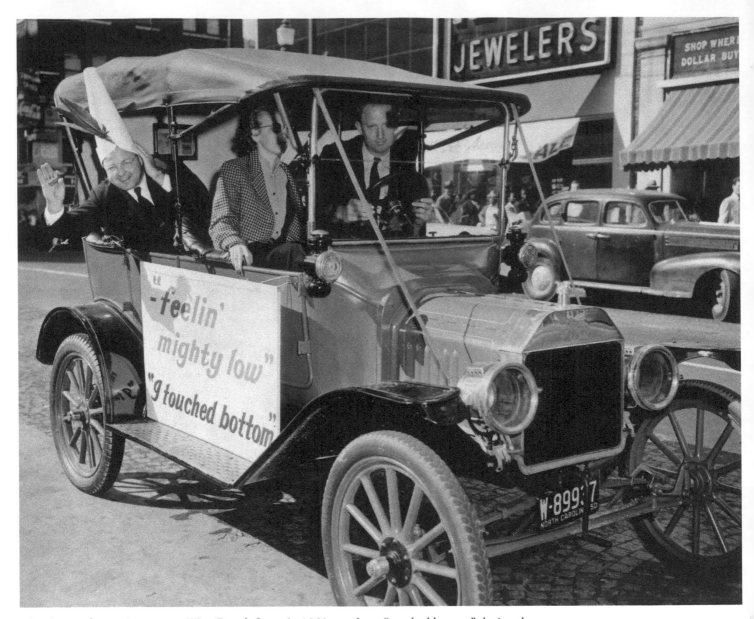

This driver of an antique car on West Fourth Street in 1950 may have "touched bottom" during the two previous decades, but like most Winston-Salem citizens, he probably believed they had turned the corner toward prosperity.

A City Redefined

(1950–1969)

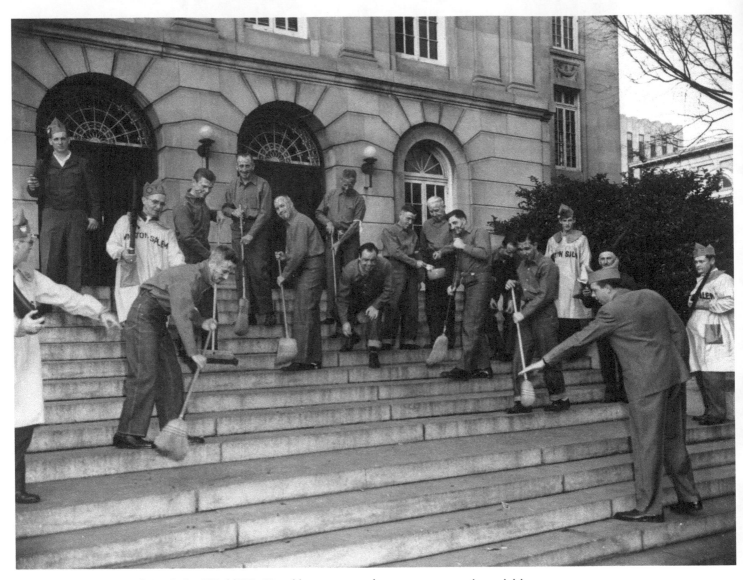

Veterans' organizations thrived after World War II and became central to many community activities. Here in 1950, American Legion members sweep the steps of City Hall.

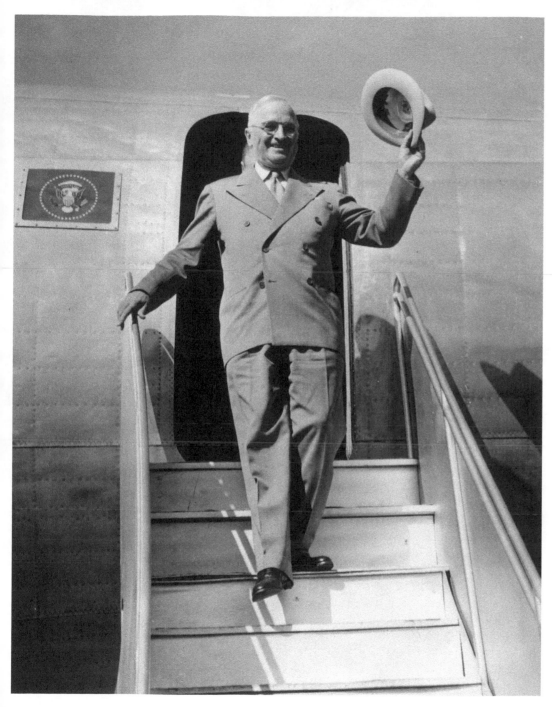

President Harry Truman flew into Winston-Salem for the Wake Forest College groundbreaking ceremonies. Here, he exits the presidential plane at Smith Reynolds Airport. On October 15, 1951, the president turned the first spade of earth to begin construction of the new facility.

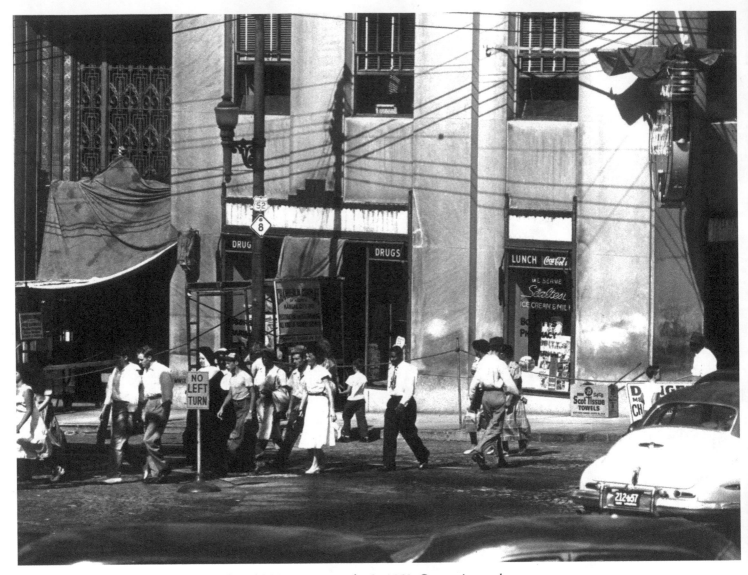

Pedestrians cross the street at West Fourth and Main on a warm day in 1950. Once prime real estate with spic-and-span family businesses lining the street, the district with its rundown, frequently changing storefronts had become reflective of downtown Winston-Salem's deterioration.

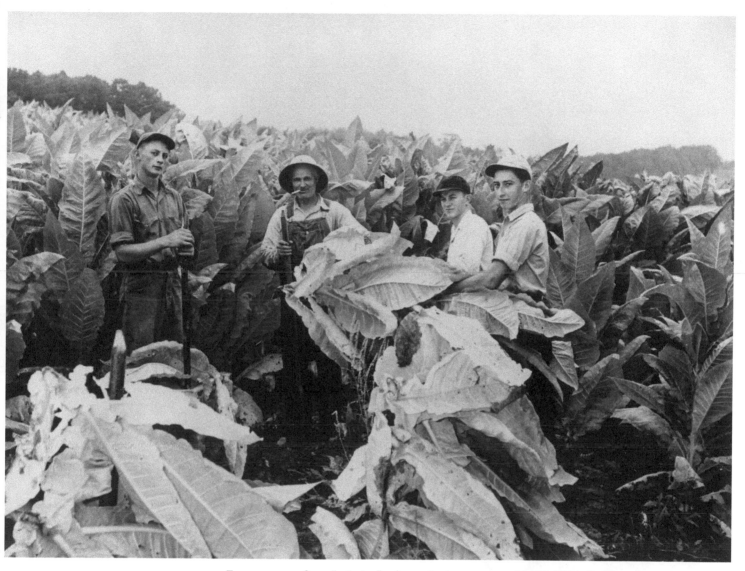

Farmers pause from "priming" tobacco in the summer of 1951. Their livelihood seemed safe, and their future liable to continue in the same pattern of beds to fields to barns to market. Then, in 1954, medical scientists began to report hazards with smoking. From small farmers to CEOs of tobacco companies, there was now more to worry about than the weather.

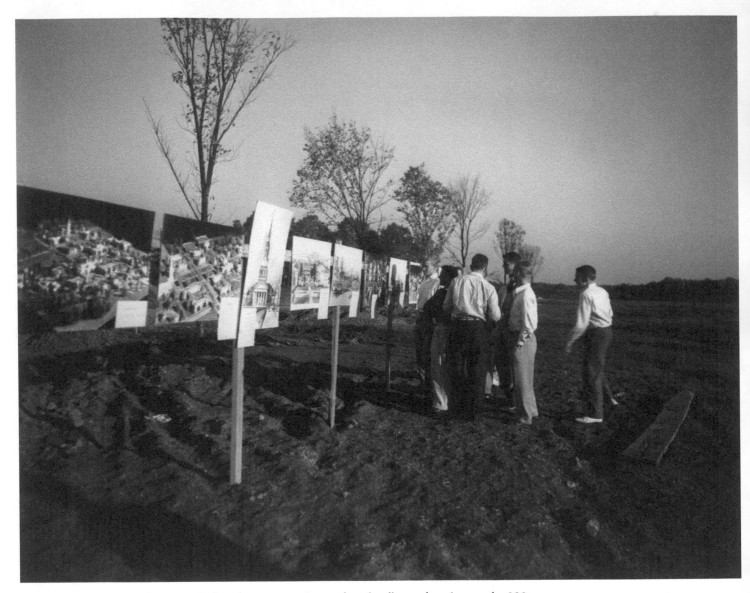

By 1952, students at Wake Forest College began appearing at the school's new location on the 320 acres of land donated to the school by Charles and Mary Reynolds Babcock. If the students in this photograph were freshmen, there is a good chance they were among the first to graduate in Winston-Salem—the college did not complete its relocation until 1956.

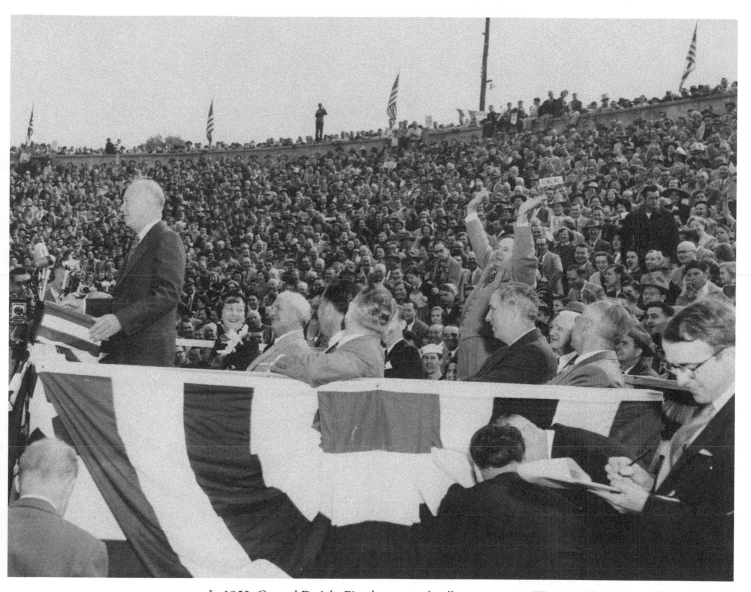

In 1952, General Dwight Eisenhower was hardly a stranger to Winston-Salem; his good friend Frank Swadley had managed the Robert E. Lee Hotel when General Eisenhower last visited in 1947. But a visit by President Truman in 1951 meant a follow-up stop on the campaign trail for Ike. This 1952 rally found cheering supporters filling Bowman Gray Stadium.

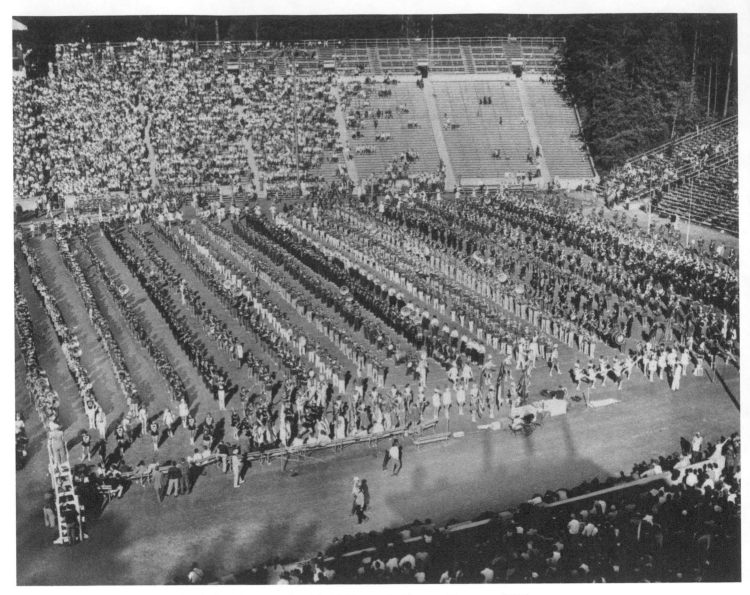

Band Day at the University of North Carolina, October 23, 1954, saw the Demon Deacons of Wake Forest drop a tough one to the Tar Heels, 14–7. With Wake Forest finishing the season 2-7-1 (1-4-1 in the Atlantic Coast Conference), some fans probably wondered if Coach Tom Rogers would be joining the team when it relocated to Winston-Salem in 1956.

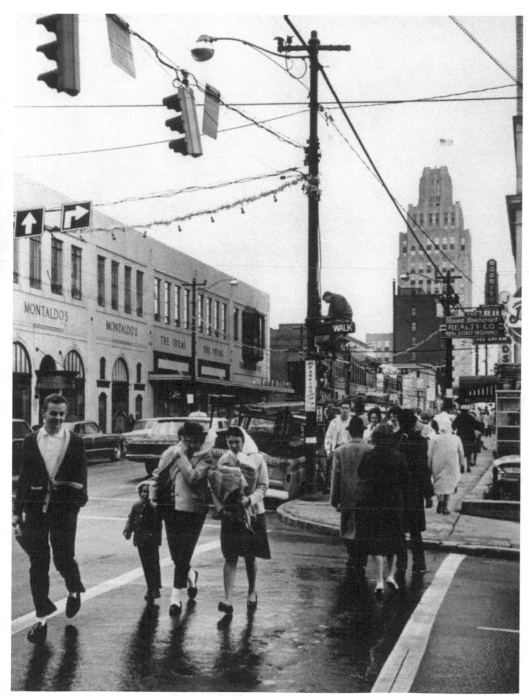

Shoppers brave the drizzle on West Fourth Street in 1955, with the Reynolds Building dominating the skyline in the background. Storefronts stand full, traffic is buzzing, and at least this part of the city seems to have recovered from the hard years of the 1930s and 1940s.

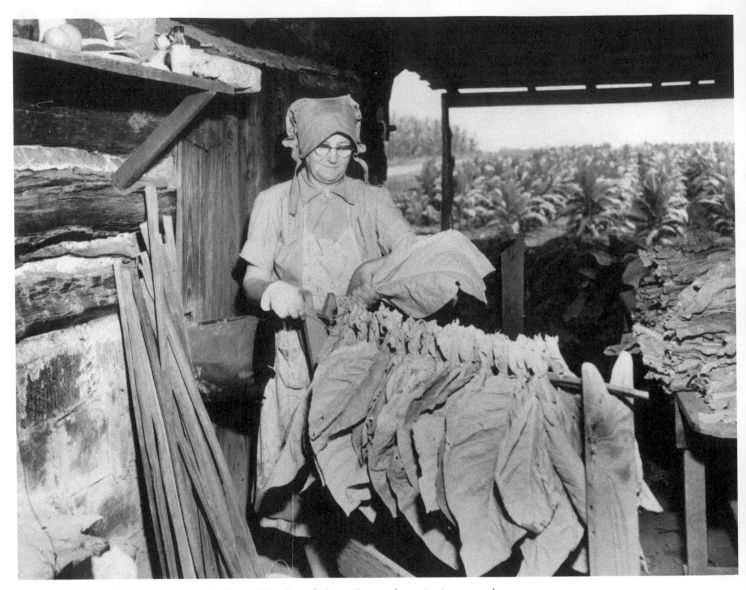

Of course, a day of shopping in the drizzle on West Fourth Street beat a day stringing wet tobacco
on the farm. The hard work had its payoff for Forsyth County's farmers, however, once those leaves
turned golden brown and made their way to the markets in the city. Then, maybe, they could join the
shopping throngs—if anything remained after paying the mortgage, taxes, and loans.

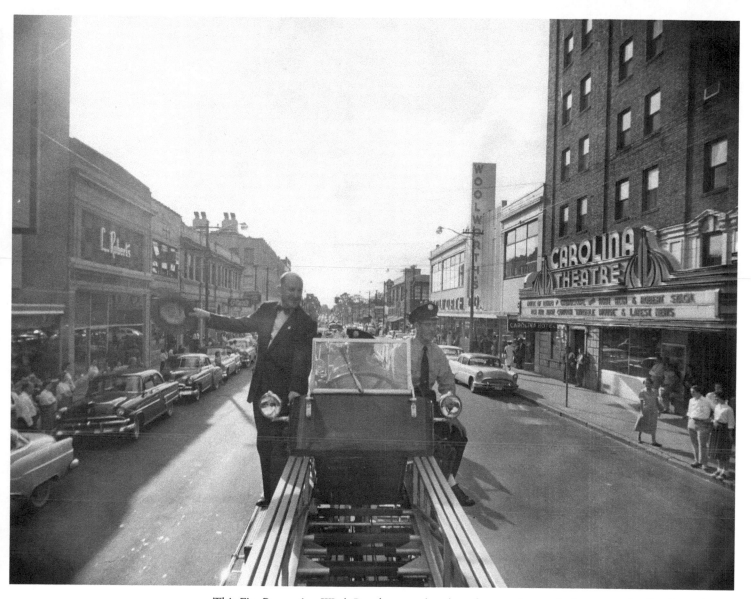

This Fire Prevention Week Parade seemed to draw few watchers as it drove past the Carolina Theatre on West Fourth Street in October 1955.

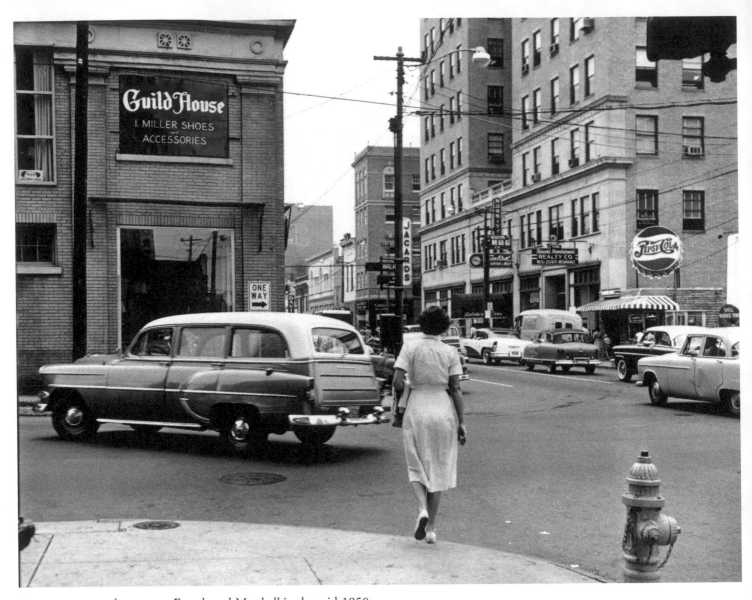

A woman crosses the street at Fourth and Marshall in the mid-1950s.

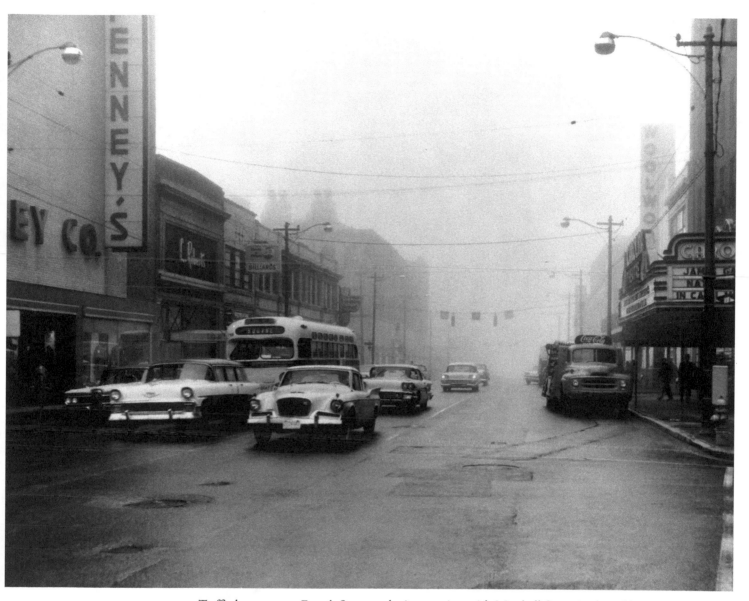

Traffic braves a wet Fourth Street at the intersection with Marshall Street in the mid-1950s. A new city transit bus is visible on the left.

An officer appears to be writing a ticket in front of the Carolina Theatre during one of the mid-1950s Christmas seasons. Parking was obviously at a premium when the big names hit the marquee. Or was someone just trying to avoid the new parking meters?

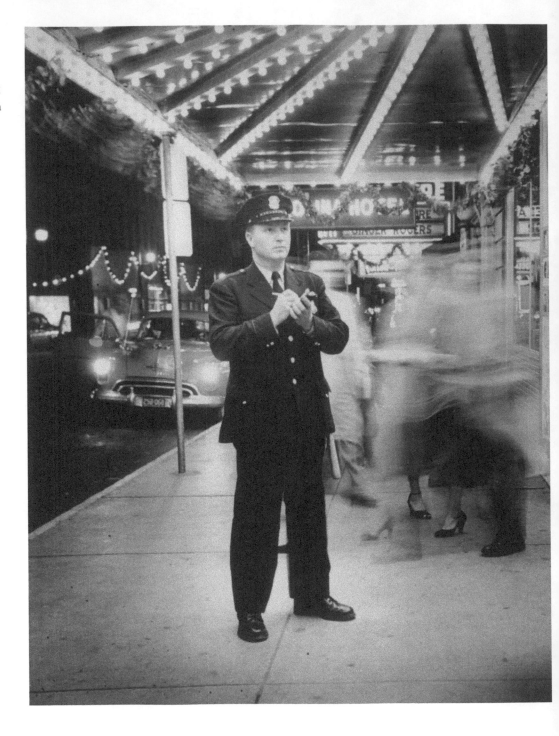

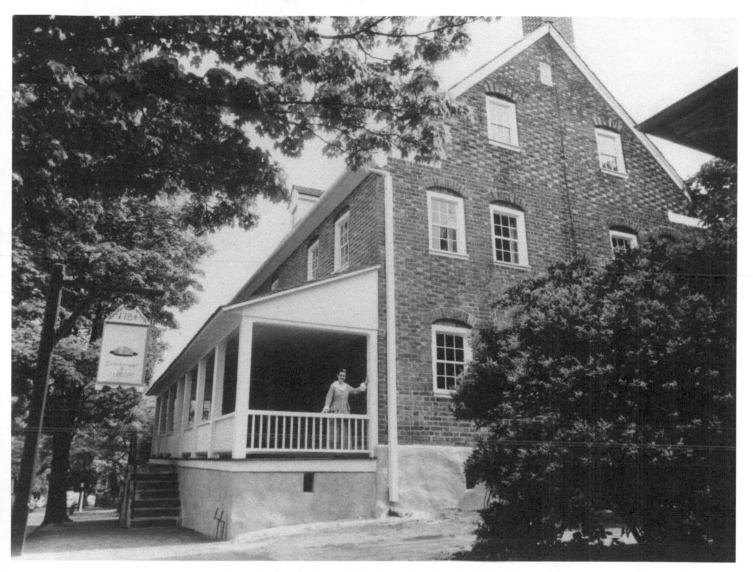

In 1947, a grocery store chain planned to demolish buildings and put a supermarket on Main Street in the middle of Old Salem. The city responded by establishing the Old and Historic Salem District and by banning new construction within the district boundaries. A non-profit corporation, Old Salem formed in 1950, with plans to restore the district. Salem Tavern became the best-known building in Old Salem. By the time of this 1956 photograph, the Wachovia Historical Society had leased the tavern building to Old Salem.

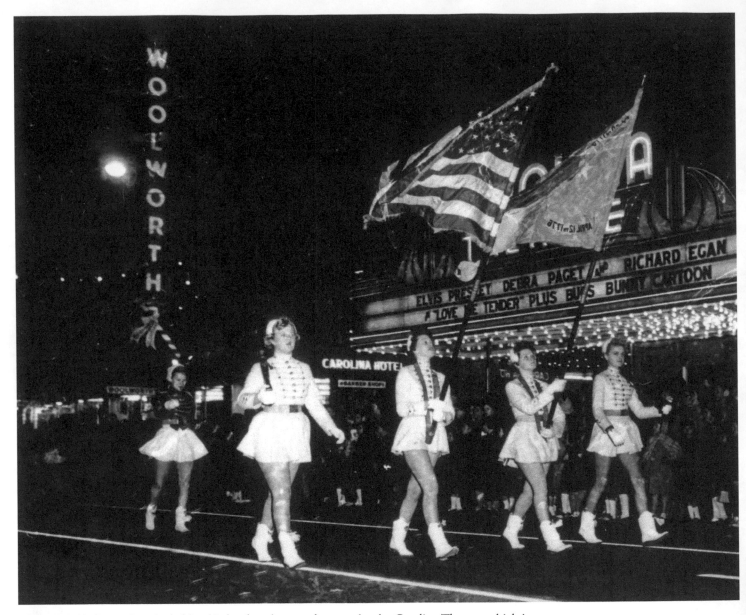

The 1956 Christmas Parade, led by this lovely color guard, passes by the Carolina Theatre, which is showing *Love Me Tender,* Elvis Presley's first movie.

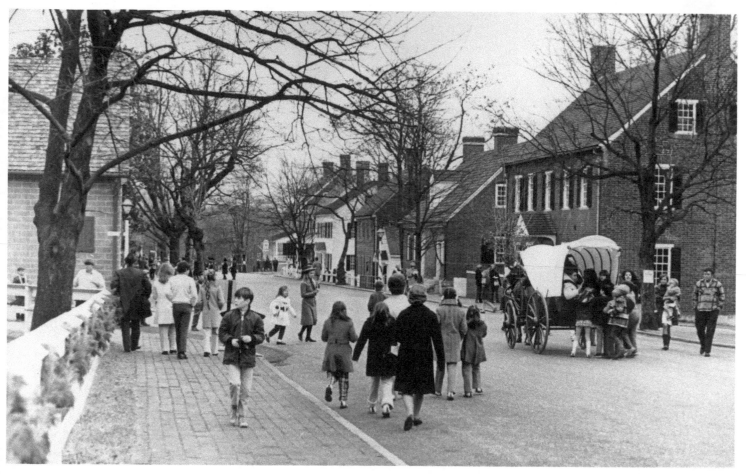

After the creation and development of Old Salem during the 1950s, the district continued to draw tourists and history buffs from around the United States.

As Wake Forest College prepared to open in Winston-Salem in 1956, the entrance arch, a gift from the Class of 1909, framed the campus.

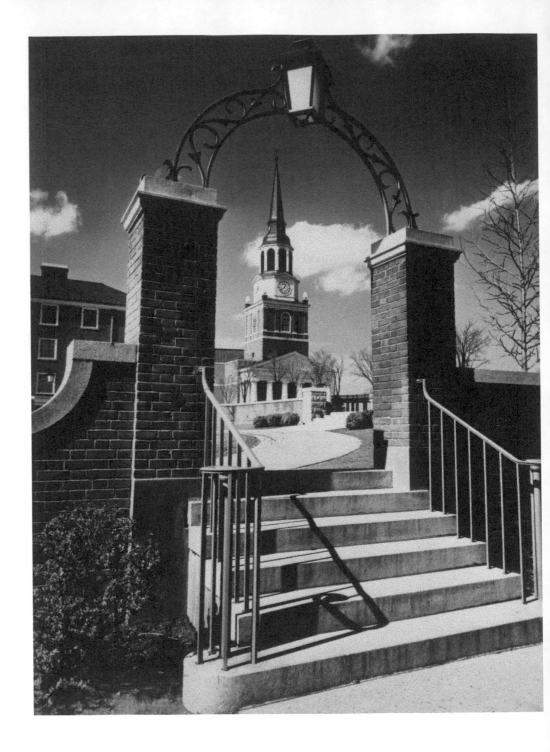

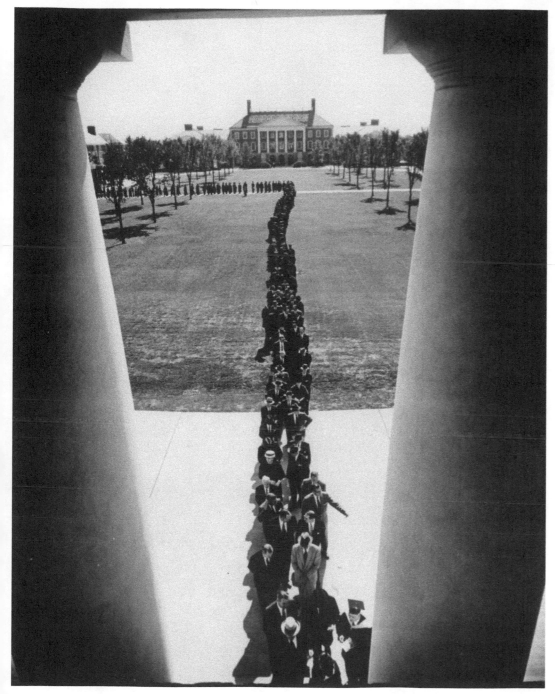

Viewed from the entrance of Wait Chapel, the processional for the 1956 dedication of Wake Forest College took place with Reynolda Hall in the background, across the plaza.

The 1956 Christmas Parade, held at night, drew a large crowd as it rumbled down Fourth Street.

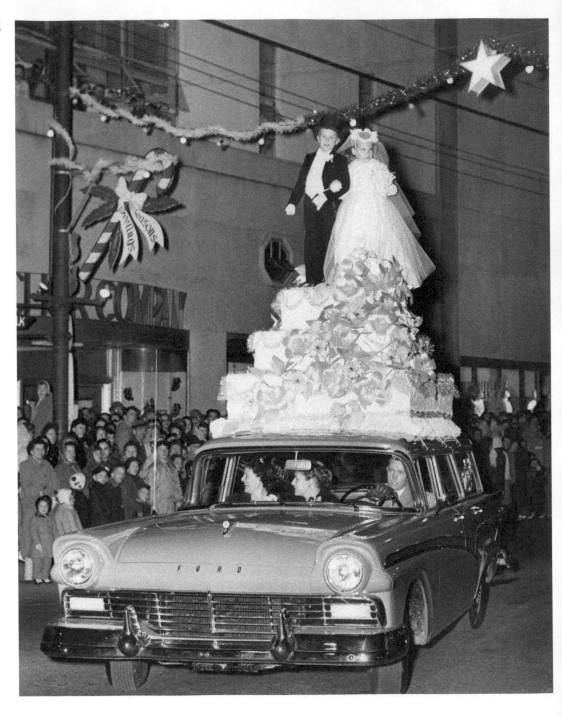

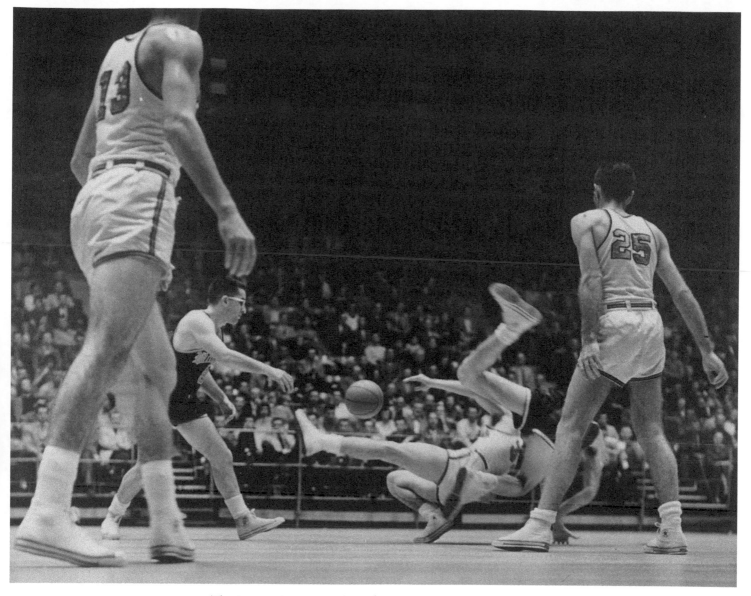

The Demon Deacons took on the University of Virginia Cavaliers in 1957. Wake Forest coach Bones McKinney must have been screaming over this collision!

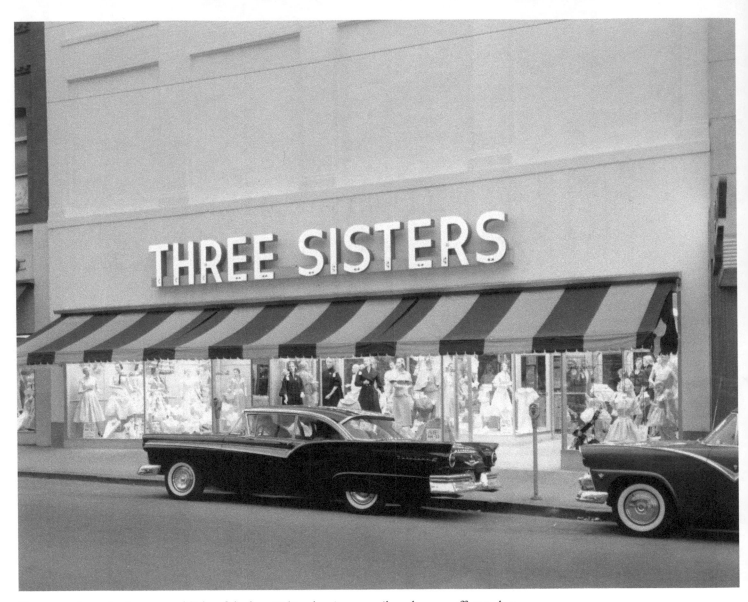

To recover from the downtown blight of the late 1940s, the city council made every effort to lure chain stores, such as this Three Sisters department store on North Liberty Street, to the Winston-Salem area. Visible in this 1957 view are parking meters, which also provided much-needed revenue.

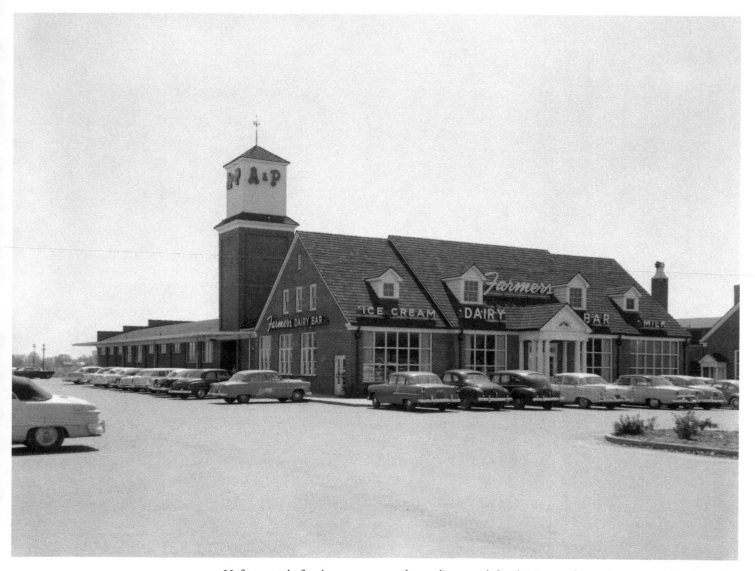

Unfortunately for downtown, merchants discovered that businesses located next to major shopping destinations in the suburbs, such as this new A&P grocery store on Stratford Road, had immense profitability. Farmers Dairy Bar seems to be enjoying great business, despite the fact that this was a chilly January day in 1958.

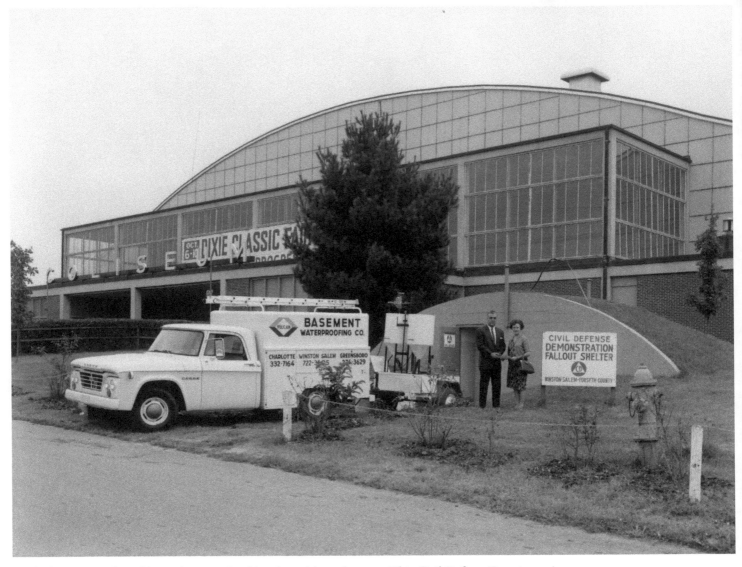

By the late 1950s, the cold war threatened to blaze hot with nuclear war. This Civil Defense Demonstration Fallout Shelter probably caught the eyes of many people attending events at the coliseum.

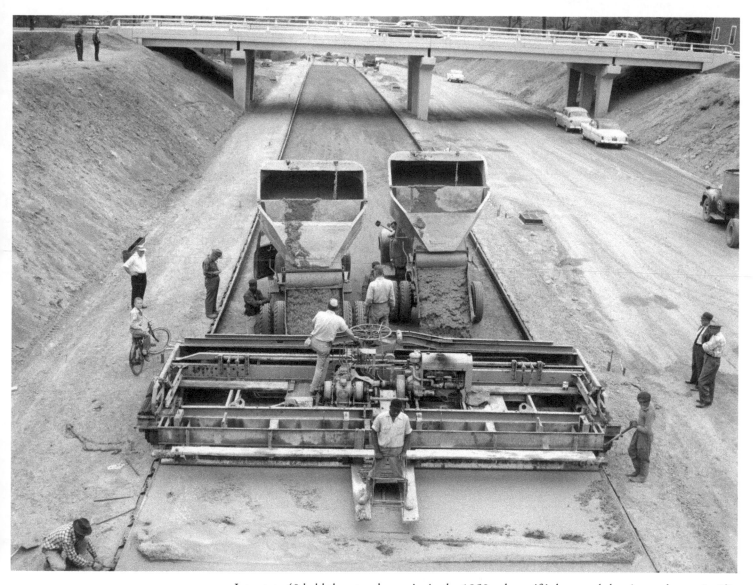

Interstate 40 held threat and promise in the 1950s: threat if it bypassed the city, and promise if it went through the city, thus eliminating downtown traffic congestion and beckoning travelers. Mayor Kurfees and city leaders lobbied for the downtown expressway. They won, and the unfortunate result was the dangerous Hawthorne Curve, a mile of 6 percent grade followed by a vicious 10-degree curve. Here around 1958, workers grade part of I-40.

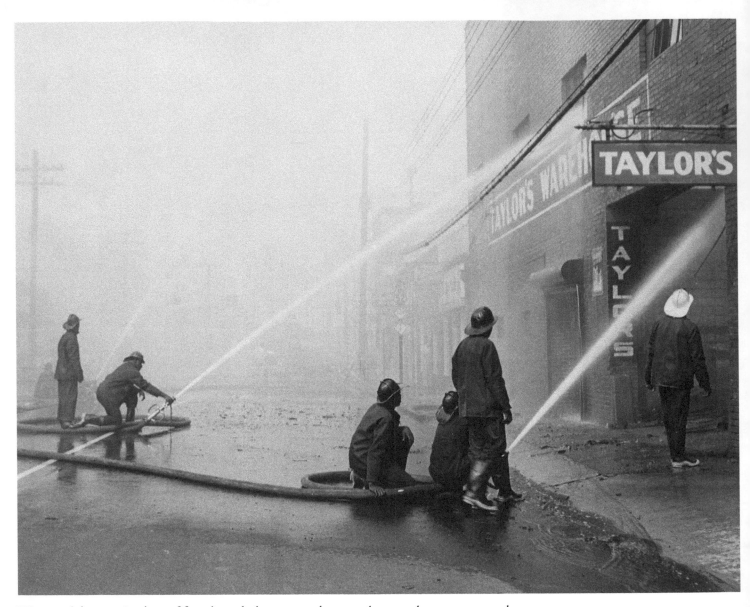

Winston-Salem saw its share of fires through the years, and among the most dangerous were tobacco warehouse fires. Seldom could fire fighters save a tobacco warehouse, no matter their training or equipment, and the smell of burning tobacco would waft on the breeze until the flames consumed the structure. Such was the case with the Taylor's Warehouse blaze in 1958.

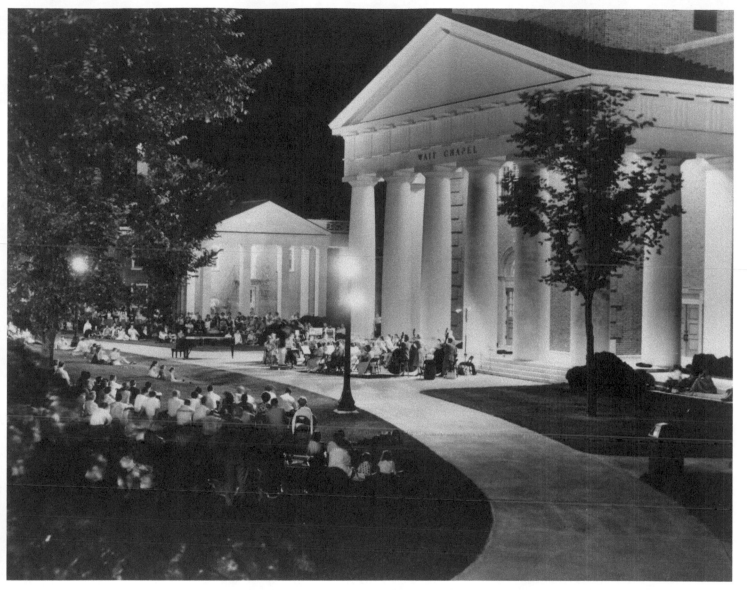

Wait Chapel, on the campus of Wake Forest, glows behind this evening music performance in 1958.

Shoppers rush along a cold,
stormy Fourth Street in 1958.

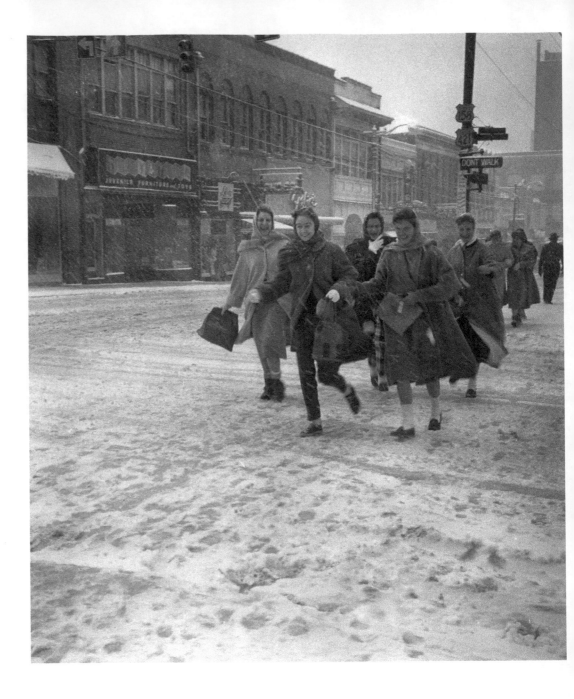

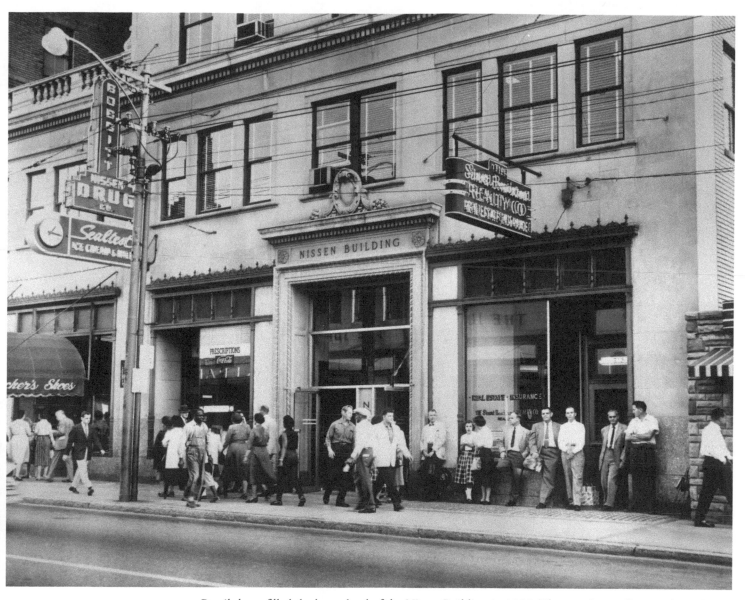

Retail shops filled the lower level of the Nissen Building in 1958. The people standing on the right are probably waiting for a city transit bus.

The building of the East-West Expressway threatened the destruction of a city icon: the giant coffee pot that stood in front of the soon-to-be-demolished J. E. Mickey Shop. In 1959, rather than lose such a valued part of its history, the city relocated the coffee pot to its current location on Main Street.

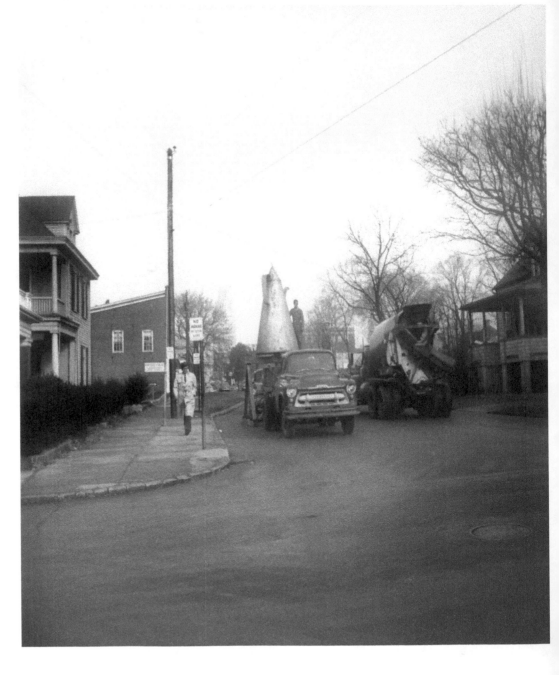

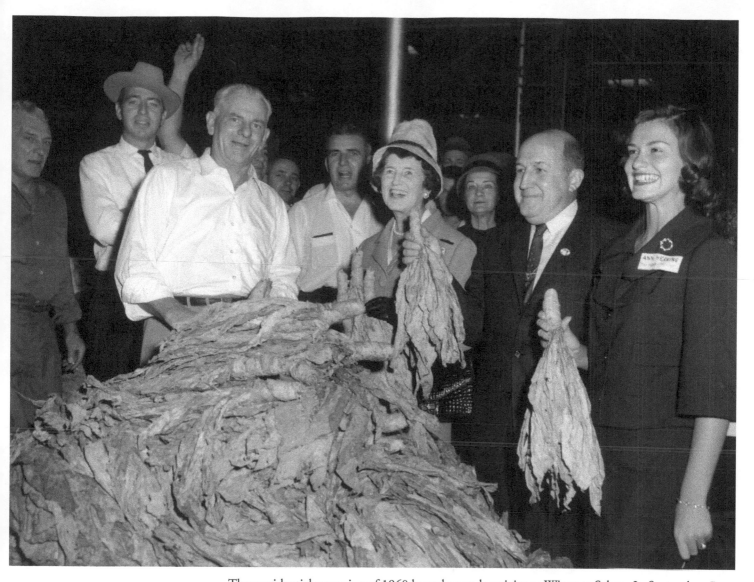

The presidential campaign of 1960 brought much activity to Winston-Salem. In September, Rose Kennedy, at center, stumped for her son John as the tobacco market brought farmers into town. The man to the right of the Kennedy matriarch is Mayor Kurfees, and to the right of him is Miss North Carolina, Ann Herring.

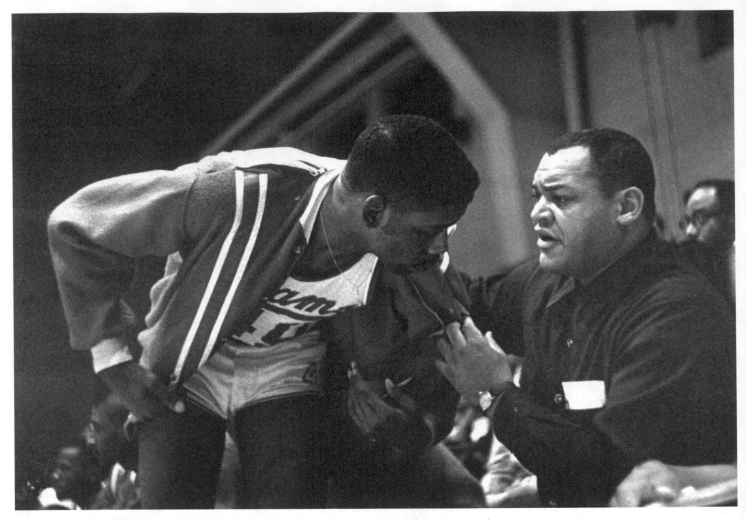

Coach Clarence Gaines, pictured at right in 1961, is a basketball legend. While he was coach at Winston-Salem State, from 1946 until his retirement in 1993, his teams won 828 games and 12 CIAA championships. Coach Gaines ranks fifth on the NCAA's list of basketball coaches with the most wins.

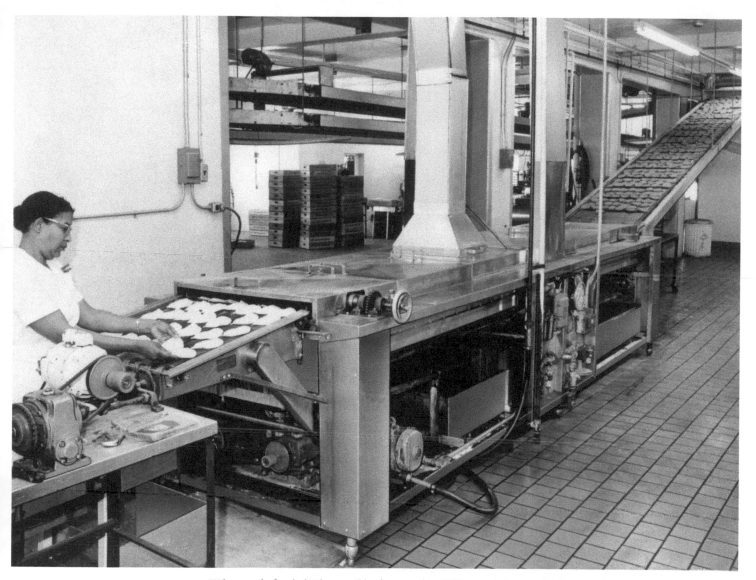

Who needs fried chicken and barbecue when Winston-Salem is the home of a true Southern delicacy: Krispy Kreme doughnuts! Vernon C. Rudolph and partners made the first Krispy Kreme doughnuts in a rented building across from Salem College in 1937. They developed an automatic production line in the 1950s. The lady in this picture is preparing some of the last cut doughnuts in 1961. Beginning the following year, the doughnuts were extruded—and still delicious.

Many aging theaters, like the Carolina Theatre, also found use as general-purpose meeting sites and local cultural centers. Here, ladies of Winston-Salem organize for the March of Dimes in 1964. In 1983, a remodeled Carolina Theatre became the Roger L. Stevens Center for performing arts.

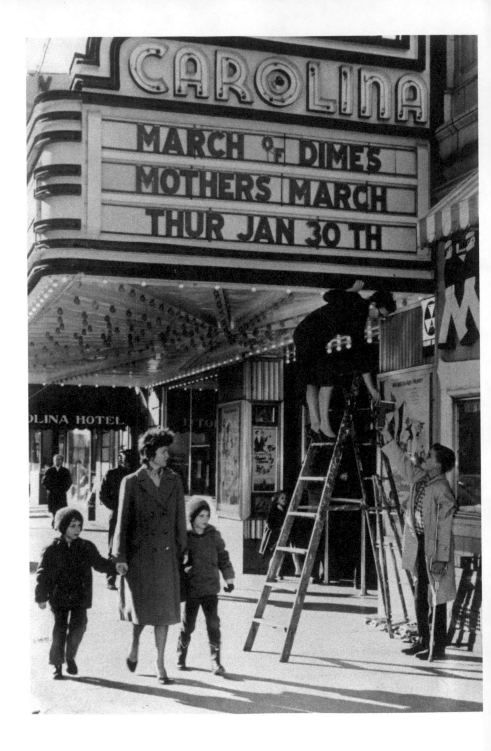

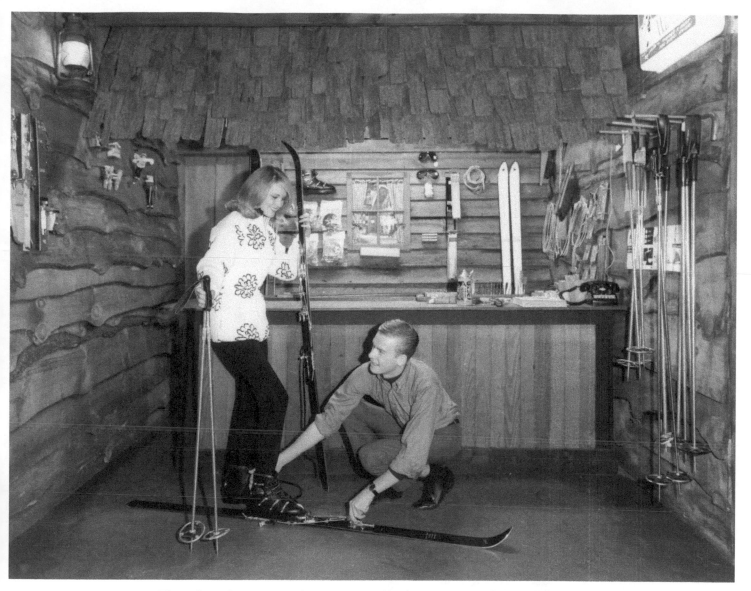

The early 1960s saw many Americans stressing the importance of physical fitness, a legacy of John F. Kennedy's initiatives before his assassination. Skiing was the theme at Sportsman's Supply in October 1964.

The 12-story Hotel Robert E.
Lee towered at the corner of West
Fifth and North Cherry streets
from 1921 until its demolition
in 1972, as it made way for the
Winston-Salem Hyatt House. For
much of that time, it served as
Winston-Salem's premier hotel.

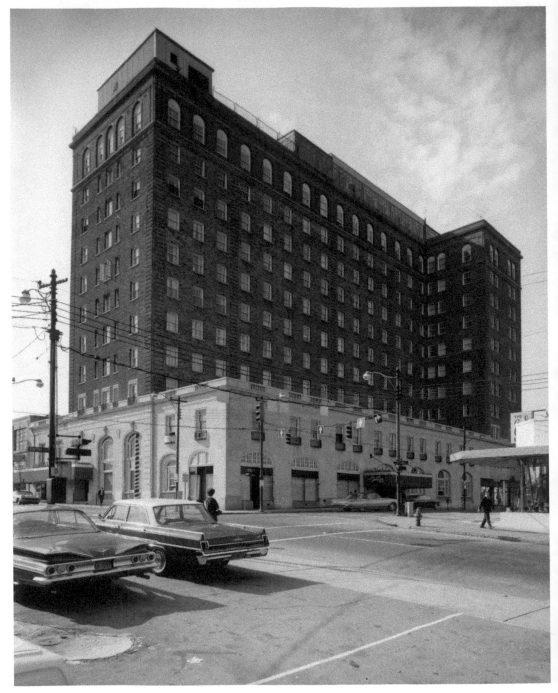

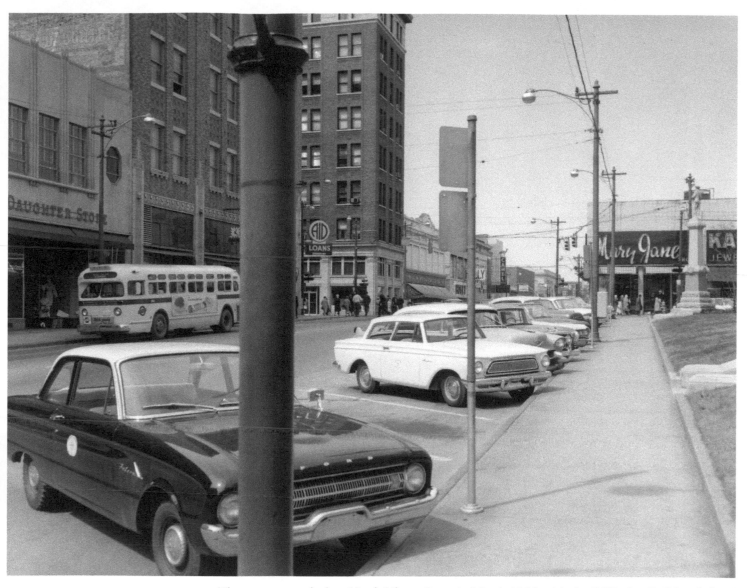

These cars are parked on North Liberty Street in March 1964, with the O'Hanlon Building behind them at center, and the Mothers and Daughters store on the left. Parking meters have disappeared and parking is now on the diagonal. The city transit bus still runs, despite an increasing shift of major shopping establishments away from the downtown area.

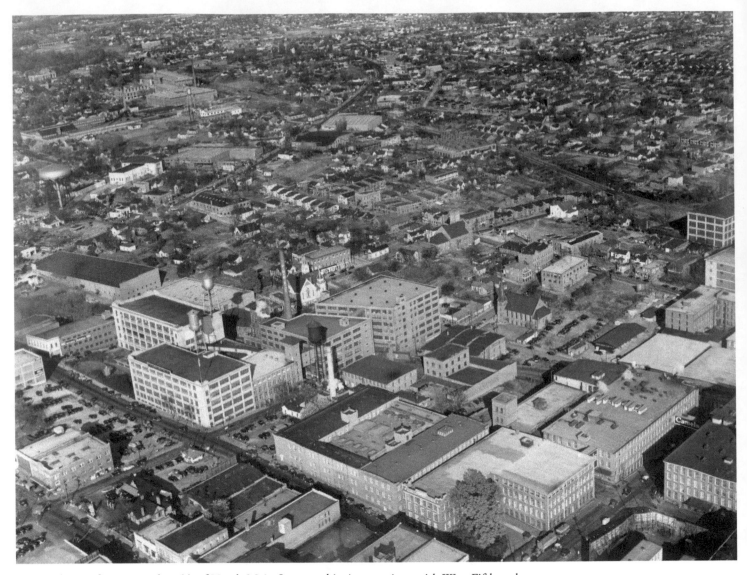

An aerial view, from around 1964, of North Main Street and its intersections with West Fifth and Sixth streets gives some sense of the massiveness of the R. J. Reynolds Tobacco Company facility, which at times employed as much as 20 percent of Winston-Salem's population.

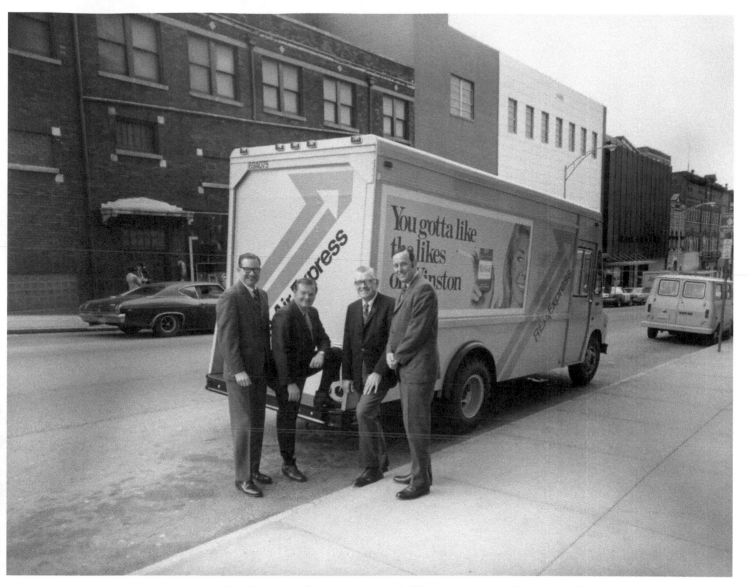

Nothing made freight carriers smile like a contract with R. J. Reynolds Tobacco Company. In this photograph from April 1970, smiling executives stand behind a REA Express truck parked near the Reynolds Tobacco Company entrance on North Main Street.

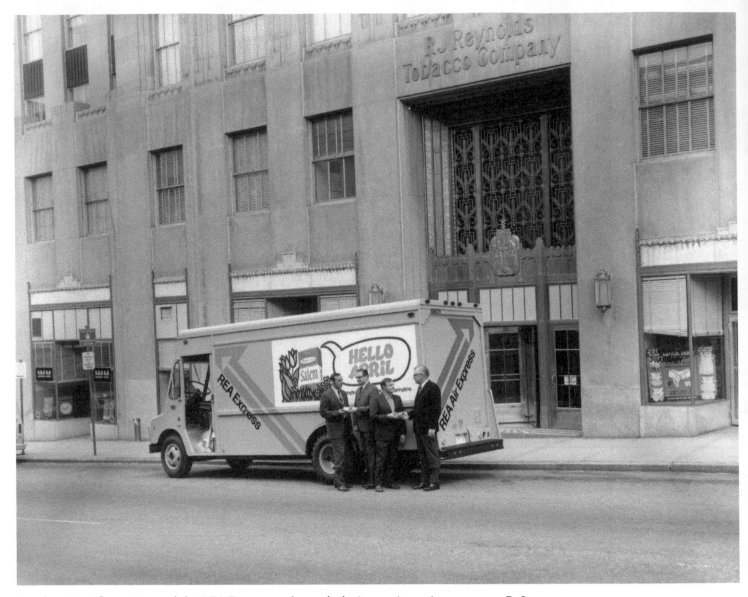

Another view of executives and the REA Express truck reveals the impressive main entrance to R. J. Reynolds Tobacco Company.

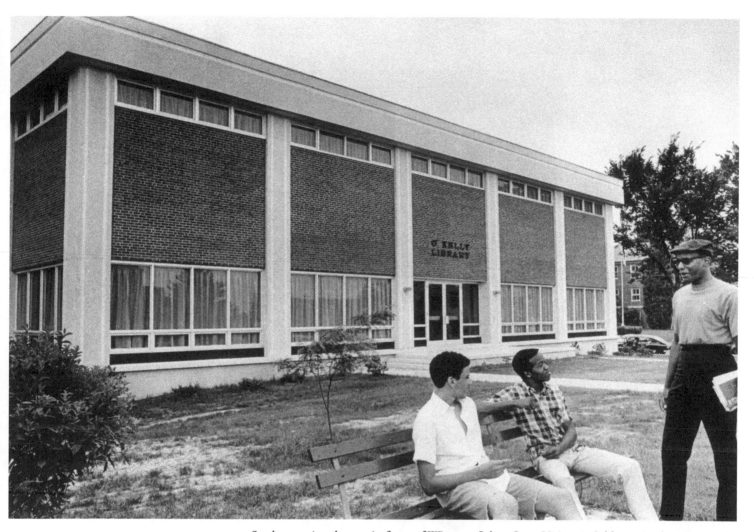

Students enjoy the sun in front of Winston-Salem State University's library in the 1960s. The historically black institution traces its origins to Slater Industrial Academy in 1892, becoming Winston-Salem Teacher's College in 1925, Winston-Salem College in 1961, and a university in 1969. Long a cornerstone of the African American community in Winston-Salem, WSSU now offers quality education regardless of an individual's race.

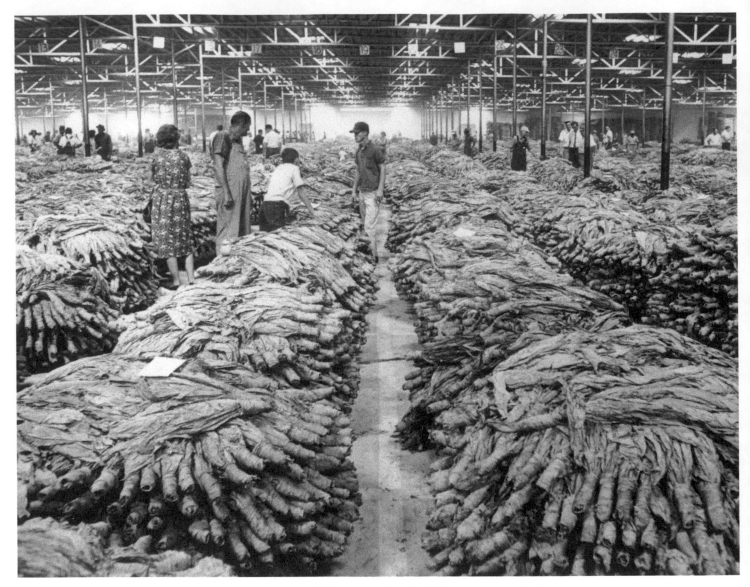

In 1969, auctioneers still chanted and farmers still sweated the results (though little sweat remained after a summer in the fields and barns), despite ever-increasing concerns over the potential dangers of smoking.

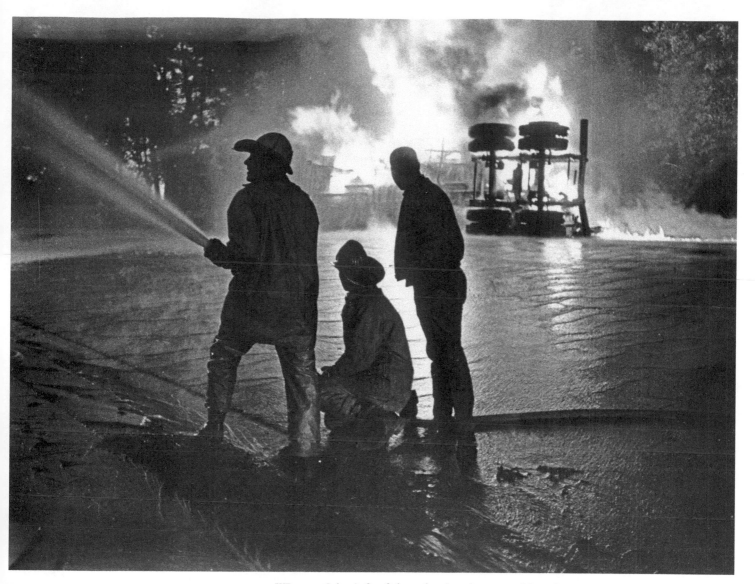

Winston-Salem's fire fighters battle a dangerous blaze from an overturned truck in 1969.

At 30 stories, the Wachovia Building reached even higher than the neighboring Reynolds Building when the Wachovia opened in 1966. It housed the offices of Wachovia Bank and numerous other businesses. Today it is known as the Winston Tower.

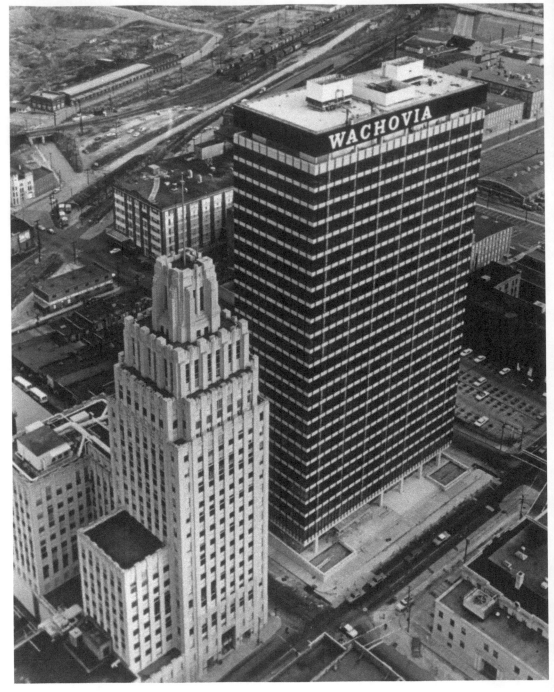

Notes on the Photographs

These notes, listed by page number, attempt to include all aspects known of the photographs. Each of the photographs is identified by the page number, a title or description, photographer and collection, archive, and call or box number when applicable. Although every attempt was made to collect all data, in some cases complete data may have been unavailable due to the age and condition of some of the photographs and records.

Printed in the USA
CPSIA information can be obtained
at www.ICGtesting.com
JSHW072026140824
68134JS00042B/3804

9 781683 369073